IMAGES
of America

St. Pete Beach's
Corey Avenue

The Corey Area Business Association (CABA) uses this brick marker as its logo. Located on Corey Avenue near Gulf Boulevard, it was installed by CABA in 1997 to draw people to the street. (Roberta L. Whipple.)

ON THE COVER: St. Petersburg Beach mayor William Coletti (left) joins a group of local officials as they ride over the original Corey Causeway to the dedication of the new St. Petersburg Beach Causeway on September 10, 1966. (City of St. Pete Beach.)

IMAGES of America

St. Pete Beach's Corey Avenue

Roberta L. Whipple

ARCADIA
PUBLISHING

Published by Arcadia Publishing
Charleston, South Carolina

Printed in the United States of America

Library of Congress Control Number: 2009924691

For all general information contact Arcadia Publishing at:
Telephone 843-853-2070
Fax 843-853-0044
E-mail sales@arcadiapublishing.com
For customer service and orders:
Toll-Free 1-888-313-2665

Visit us on the Internet at www.arcadiapublishing.com

This book is dedicated to my father, Robert L. "Doc" Lamb,
a Corey area merchant from 1949 to 1973,
and to my husband, Jon P. Whipple,
who allows me to believe that research is an acceptable hobby.

CONTENTS

Acknowledgments 8

Introduction 9

1. The Corey Causeway 11

2. The Upham Company 23

3. First Arrivals 37

4. The Beach Theatre 53

5. The Postwar Boom 61

6. City Operations 77

7. An Eclectic Group of Businesses 99

8. Special Events 115

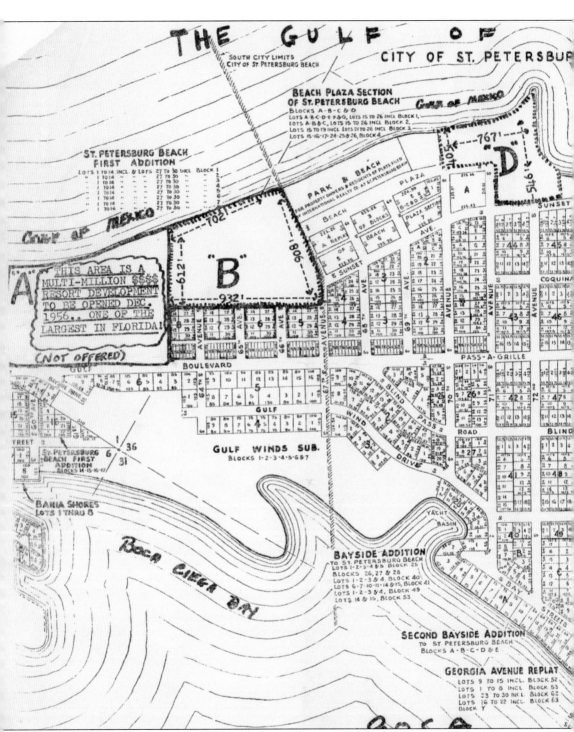

The Upham Company's holdings extended from Boca Ciega Bay to the Gulf of Mexico, between Sixty-fourth Avenue and the Blind Pass Channel. However, the city limits of the first St. Petersburg Beach (1943–1957) included only the area between Sixty-seventh and Seventy-eighth Avenues. From the beginning, Corey Avenue had been envisioned as the business center of town. Homes,

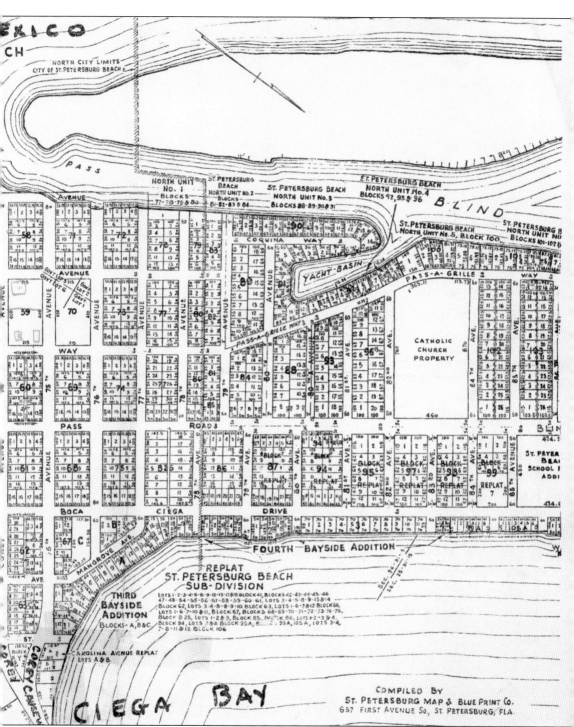

apartments, and small lodgings would be built on either side, and a beach park would be reserved exclusively for residents and visitors. The exact date of this map is unknown, but the notation at upper left about "a multi-million $$$ resort development to be opened Dec. 1956" suggests that it was created and published a little before that time. (CAU.)

7

Acknowledgments

Special thanks go to Spencer Lucas, photographer and friend, who quickly learned the scanning specifications, helped search through every picture owned by the Gulf Beaches Historical Museum, and provided snapshots of historic items when necessary. The information in this book was verified, in part, by the online files of the *St. Petersburg Times* and the *Evening Independent*.

The following people or institutions have contributed more than one image.
BH: Bill Howard
BK: Barbara Kurant
BBS: Barbara Baker Smith
CAU: Carol Ann Upham
COSPB: City of St. Pete Beach
EC: Eckerd College
EF: Eleanor Franko
GBHM: Gulf Beaches Historical Museum
GC: George Chase
HV: Heritage Village
ICT: Island Community Theatre
JSL: Spencer Lucas
MB: Marion Ballard
MF: Michael France
NPL: Nelson Poynter Library
PP: Pat Packer
PS: Phyllis Schuster
RLW: author's personal collection
SPBCC: St. Pete Beach Community Club
SPMOH: St. Petersburg Museum of History
SPT: *St. Petersburg Times*
SS: Sharon Smith
TT: *Tampa Tribune*

The author's earnings from this book are being donated to the Friends of the St. Pete Beach Library.

INTRODUCTION

Although the name was officially shortened in 1994, St. Petersburg Beach was known as St. Pete Beach long before that. Both names appear throughout this book, as both have their place in the history of the area. For more than 70 years, Corey Avenue and the area immediately around it have been known as St. Pete(rsburg) Beach's "downtown." Corey Avenue contains not only city hall but also the public library, police headquarters, a fire station, two banks, two gas stations, a funeral home, a chain drugstore, a chain grocery, a church, quite a few restaurants, and several women's clothing stores, as well as the oldest movie house in Pinellas County.

Corey Avenue takes its name from the bridge and causeway that connects St. Pete Beach with the mainland. Jack Corey was a young Pinellas County commissioner in the 1920s who lobbied hard for the funds for the span. The toll-free bridge opened in late 1927.

But it was Niel and William Upham, two very smart brothers from Wisconsin, who were largely responsible for the development of Corey Avenue. Their family's real estate and investment firm had acquired a large chunk of St. Petersburg Beach, including the area next to the new bridge, in 1928. In 1936, they took it upon themselves to shore up the road (originally a mangrove "swamp"), install utilities, and begin to erect buildings for shops. Among the first arrivals were a neighborhood bar, a small food store, ladies' beachwear shop, a doctor's office (the first on the barrier islands), a funeral home, several gas stations, a weekly newspaper, and a movie theater. William Upham became St. Petersburg Beach's first mayor in 1943.

In the years following World War II, the beaches boomed. The establishment of the Gulf Beach Bank in 1948, one block north of Corey Avenue, made it possible for many to buy homes and set up businesses. The ladies' beachwear shop moved from its space next to the food store into a much larger storefront. It was soon joined by a men's clothing store, a children's clothing store, two full-service drugstores, an optometrist and a dentist, a hardware store, a newsstand, two florists, a marine construction company, a library, a community center, a chamber of commerce, more gas stations, a small amusement park, a 24-hour diner, a couple of gift shops, and a branch of the local electric company.

In 1957, when all four towns on Long Key merged into St. Petersburg Beach, it was fairly obvious where city offices would be: the strategically located Corey area. One of the government's first building projects was a sleek, modern city hall just off Seventy-sixth Avenue.

That same year, the *Polk City Directory* for the Gulf beaches compared Corey Avenue to New York's Fifth Avenue, "a thoroughfare of swank, ultra-modern shops displaying high-grade merchandise."

Of course, in the time since, many of the original businesses have closed, and others have come to take their places. Two two-lane bridges constructed in 1966 and 1975 have diverted a large amount of the traffic to Seventy-fifth Avenue. But the Corey area remains, in many minds,

St. Pete Beach's "Main Street."

Outdoor art shows fill Corey Avenue in January, April, June, and December. City hall has relocated to the east end of Corey Avenue. The annual Holiday Land Parade marches through Corey Avenue.

In 2007, screenwriter Michael France, a St. Pete Beach resident, purchased the Beach Theatre. His free Saturday kids' matinees and innovative programming have increased recognition of Corey Avenue.

The Corey Area Business Association organizes special events, coordinates advertising, and pays for an informative Web site.

And a daughter of the owner of the first independent drugstore (this author) runs the public library.

One

THE COREY CAUSEWAY

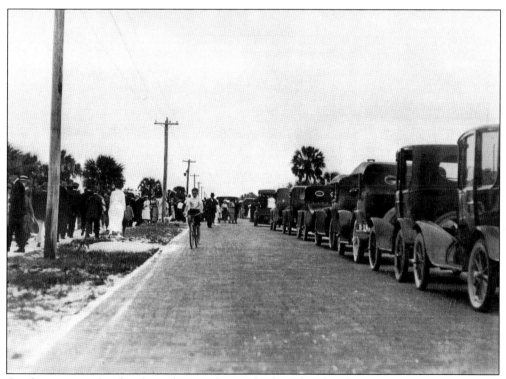

On almost any weekend in the mid-1920s, thousands of people in hundreds of cars from St. Petersburg, and even Tampa, headed to the beach at Pass-a-Grille. (GBHM.)

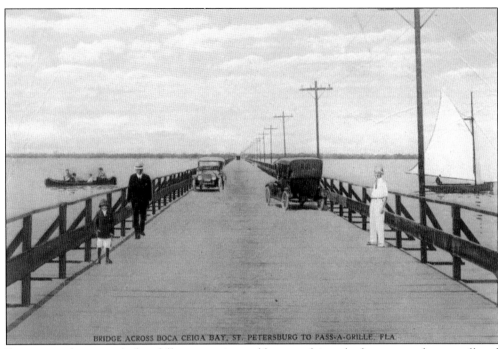

BRIDGE ACROSS BOCA CEIGA BAY, ST. PETERSBURG TO PASS-A-GRILLE, FLA.

But getting there wasn't the idyllic scene pictured here, as drivers had to stop and pay a toll and then proceed across a long, narrow, wooden-plank bridge at a speed of no more than 10 miles per hour. (GBHM.)

The lack of a decent access road, however, did little to discourage investors like New York Yankees owner Jacob Ruppert from buying up large amounts of real estate on the island—and bringing in even more traffic. (SPMOH.)

12

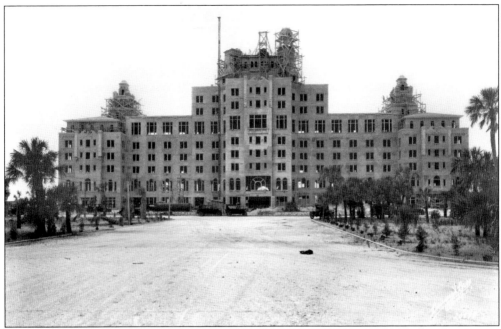

Thomas J. Rowe had poured all his assets into the creation of a luxury hotel, the Don Ce-sar. Anxiously watching his Long Key resort take shape, Rowe led the drive for an improved highway system for the lower Pinellas beaches. A $1,275,000 bond issue to fund it passed overwhelmingly on November 13, 1925. (GBHM.)

However, before the project could begin, it needed the stamp of approval from the state. S. Jack Corey, the county commissioner from St. Petersburg and longtime supporter of the free causeway plan, took it upon himself to travel to Tallahassee to get the required authorizations. (The Corey family.)

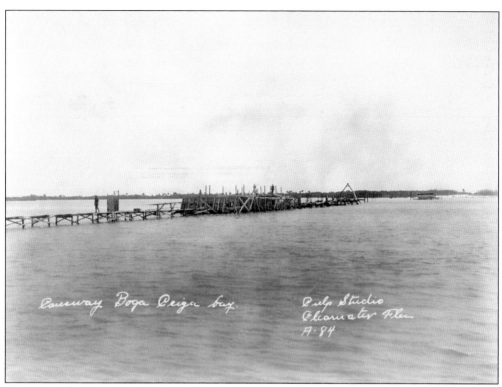

Once started, construction progressed quickly. Two hundred men were hired in May 1927 to drive pilings, install steel fittings, and pour the cement, sand, and shell mixture. This time, the bridge would run from the southernmost point of Pasadena to the broadest section of Long Key. (HV.)

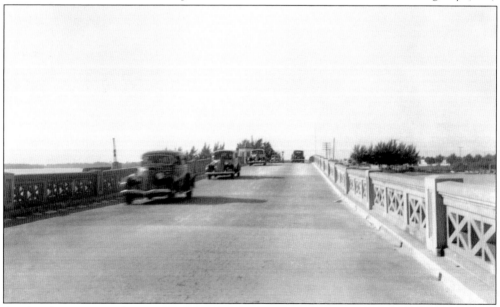

On October 30, 1927, the Boca Ciega Causeway opened to the public. At 2,800 feet long—less than half the length of the old wooden bridge—it had a 30-foot-wide bed, a 60-foot draw span, and ornamental Grecian-style railings. (CAU.)

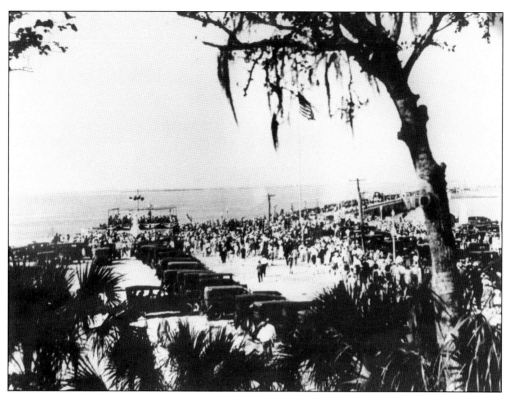

A formal dedication was delayed until February 28, 1928, during St. Petersburg's annual Festival of States celebrations. Officials of St. Petersburg, Gulfport, and Pass-a-Grille delivered speeches from a large stage on the Long Key side of the bridge and then escorted a big motorcade to an all-day regatta at Pass-a-Grille. (GBHM.)

The 1925 referendum also included financing for links to Treasure and Madeira Islands, as well as the upgrade of roads from Pass-a-Grille to the Welch Causeway. The result was a scenic motoring "loop," from St. Petersburg to the beaches and back to the mainland at Seminole. (BK.)

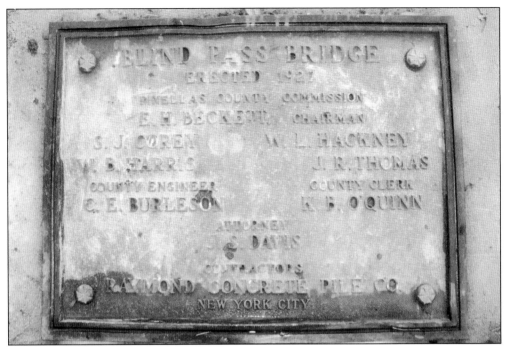

The plaque from the Blind Pass Bridge connecting St. Petersburg Beach and Treasure Island has been preserved at the Gulf Beaches Historical Museum. Among the names inscribed on it is that of county commissioner S. J. Corey. (JSL.)

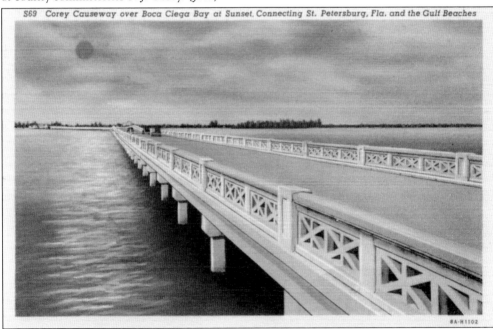

Shortly after winning reelection to the Pinellas Commission by the largest margin in history and being unanimously chosen as its chair, S. J. "Jack" Corey fell very ill and died. His legacy was guaranteed when, one week after his passing, in August 1929, the county voted to change the name of the bridge to the Corey Causeway. (GBHM.)

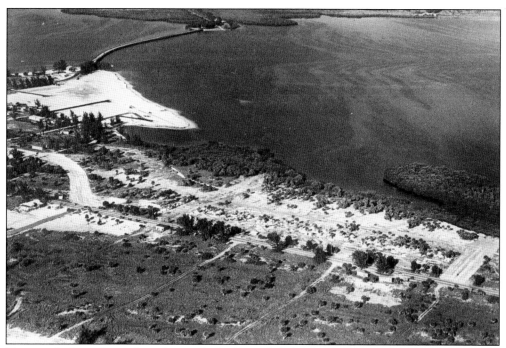

Two months later, the stock market crashed, effectively halting any economic benefit the new bridge was expected to bring. For almost 10 years, the area around the causeway remained undeveloped, a mere thoroughfare to Pass-a-Grille. (HV.)

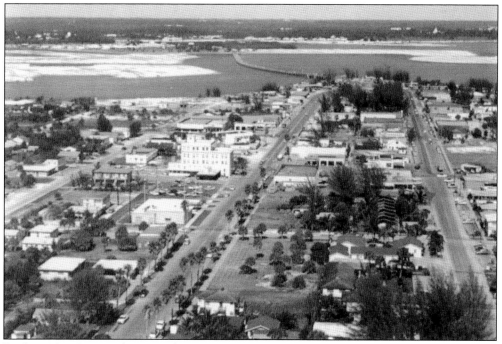

By the 1960s, St. Petersburg Beach, now a city encompassing all of Long Key, was really growing. The rising population and an international campaign for tourists brought more congestion than the two-lane Corey Causeway could handle. (RLW.)

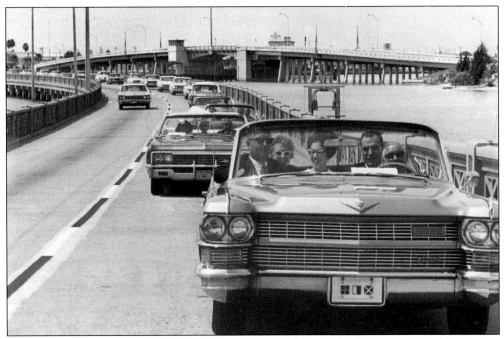

The solution was adding another span to the west of the 1927 bridge. A structure finished in 1966 doubled the highway's capacity by carrying all cars headed south; all cars headed north continued on the original span. The state assumed responsibility for the road and renamed it the St. Petersburg Beach Causeway. (COSPB.)

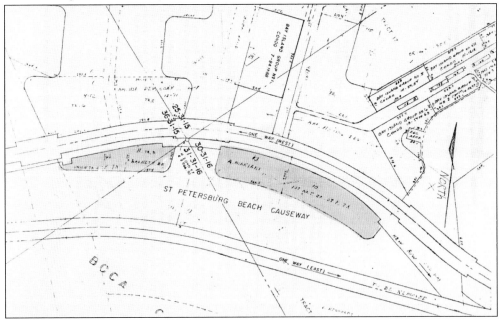

Significantly, for the first time, the causeway was not just a bridge. It ran through parcels of land previously skirted or only recently formed. The valuable property was annexed by voters in the adjacent city of South Pasadena on February 14, 1967. St. Petersburg Beach was counting on an act of the Florida Legislature, which was not meeting until the spring. (COSPB.)

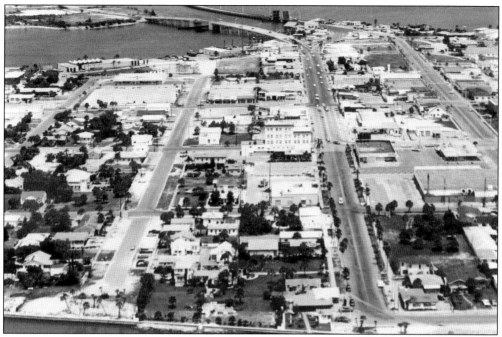

Another important change involved the point where cars exited the southbound bridge. It was no longer Corey Avenue but Seventy-fifth Avenue. Nervous Corey Avenue business owners began to look for ways to attract customers back to their street. (RLW.)

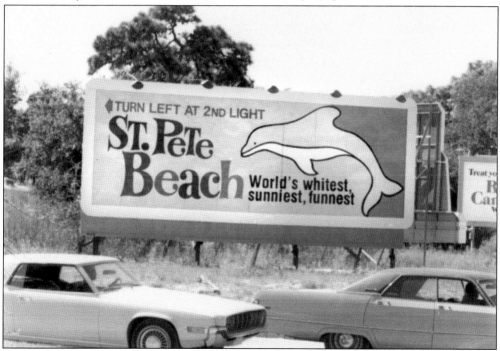

For its part, the chamber of commerce sponsored billboards directing drivers to St. Petersburg Beach across its still toll-free causeway. The Pinellas Bayway, a toll road completed in 1962, was expected to further divert travelers away from the old north side of town. (COSPB.)

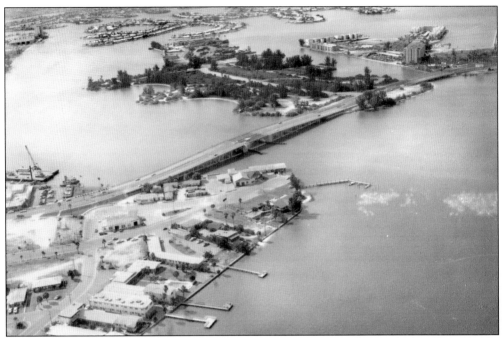

A study in the early 1970s, however, revealed that the Bayway was having little effect. The St. Petersburg Beach Causeway was found to be the second-busiest bridge in Pinellas County—after the Howard Franklin "Frankenstein" Bridge. Monies for a second new span suddenly became available. (GBHM.)

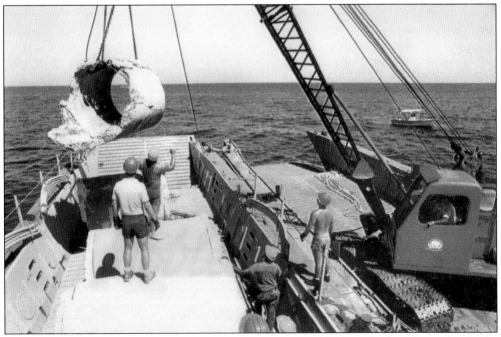

Demolished in 1976, the 1927 Corey bridge was given a second life as the foundation for the St. Petersburg Beach Artificial Reef, 5 miles out from Pass-a-Grille in the Gulf of Mexico. Here army reservists are enriching the site with pieces of concrete in 1991. (TT.)

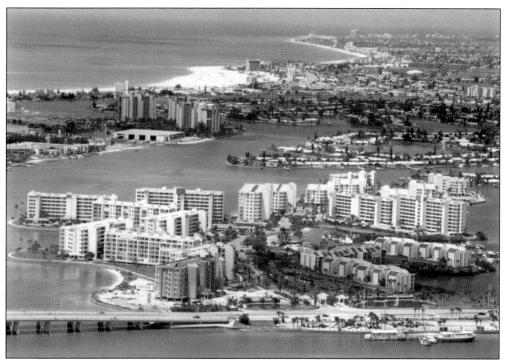

The Bay Islands Club condominiums, built in 1972, opened the door for multifamily residential housing on the causeway. This photograph was shot in 1991 as the final tower of Sailboat Key, another group of condos, was going up. (Linda Hawkins.)

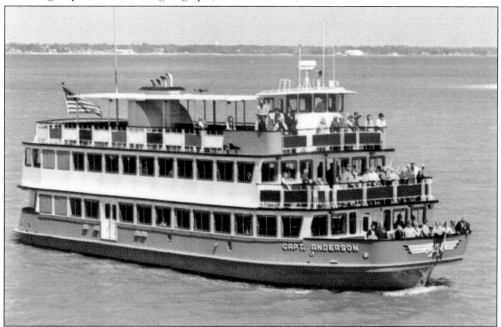

The *Captain Anderson*, a pleasure boat featuring dining and dancing, was granted permission to set up a dock on the east side of the causeway in 1984. The county commission hoped it would help to limit density. (GBHM.)

To old-timers, the bridge from St. Petersburg to St. Pete Beach never stopped being the Corey Causeway. In 1995, the Corey family persuaded the Florida Legislature to give it back its original name. (JSL.)

Two

THE UPHAM COMPANY

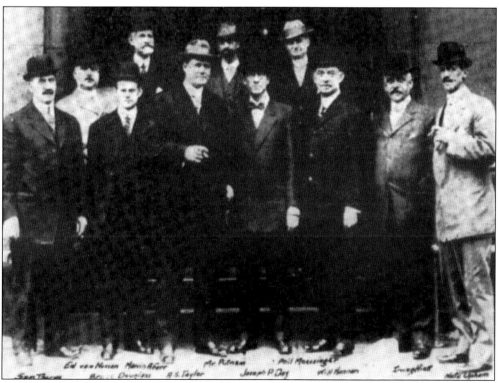

In Florida's highly unregulated land boom, Nathaniel J. "Nate" Upham was the rare professional. Seen at far right here with the other founders of the National Association of Real Estate Exchanges, he later served as the organization's president. In 1913, the board appointed him president of its investment company, International Realty Associates (IRA). (National Association of Realtors.)

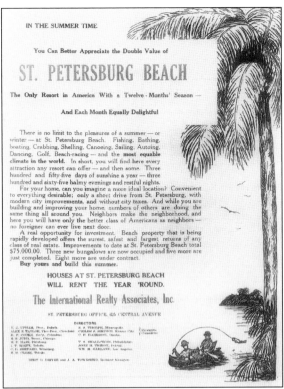

IN THE SUMMER TIME

You Can Better Appreciate the Double Value of

ST. PETERSBURG BEACH

The Only Resort in America With a Twelve-Months' Season —

And Each Month Equally Delightful

There is no limit to the pleasures of a summer — or winter — at St. Petersburg Beach. Fishing. Bathing. boating. Crabbing, Shelling, Canoeing, Sailing, Autoing. Dancing. Golf, Beach-racing — and the **most equable climate in the world.** In short, you will find here every attraction any resort can offer — and then some. Three hundred and fifty-five days of sunshine a year — three hundred and sixty-five balmy evenings and restful nights.

For your home, can you imagine a more ideal location? Convenient to everything desirable; only a short drive from St. Petersburg, with modern city improvements, and without city taxes. And while you are building and improving your home, numbers of others are doing the same thing all around you. Neighbors make the neighborhood, and here you will have only the better class of Americans as neighbors — no foreigner can ever live next door.

A real opportunity for investment. Beach property that is being rapidly developed offers the surest, safest and largest returns of any class of real estate. Improvements to date at St. Petersburg Beach total $75,000.00. Three new bungalows are now occupied and five more are just completed. Eight more are under contract.
Buy yours and build this summer.

HOUSES AT ST. PETERSBURG BEACH
WILL RENT THE YEAR 'ROUND.

The International Realty Associates, Inc.

ST. PETERSBURG OFFICE, 625 CENTRAL AVENUE

DIRECTORS

IRA ventures brought Upham to St. Petersburg about 1919. The firm had successfully attached itself to promising properties in seven states. The St. Petersburg beaches, largely untouched, now looked very worthwhile. (SPMOH.)

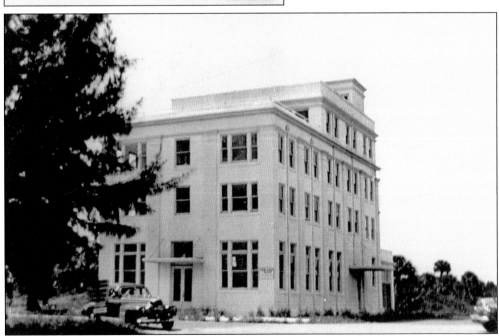

St. Petersburg Beach was then owned by the builder of this imposing structure, William McAdoo. The temperamental—and, some would say, self-serving—man sold his St. Petersburg Beach holdings to International Realty Associates and then decided he wanted them back. Upham sued, commencing litigation that would continue between the two for many years. (GBHM.)

24

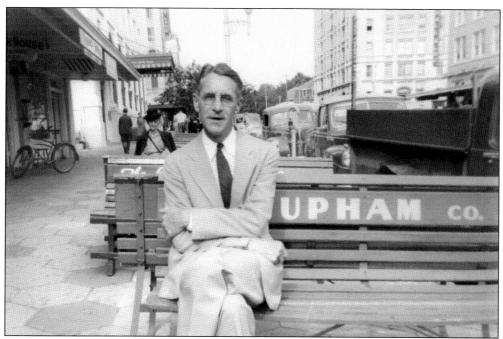

It wasn't long before Nate's sons—Niel, an experienced banker, and William, a graduate of MIT's engineering school—moved to St. Petersburg and formed the Upham Company. The slightly older Niel, seen here, was president; William was secretary/treasurer. (MB.)

THE **UPHAM** CO.

39 Fourth St. South

INVESTMENTS, CONSULTANTS
MUNICIPAL AND COUNTY BONDS
REAL ESTATE BONDS AND STOCKS
MORTGAGE LOANS
INSURANCE AND SURETY BONDS
GENERAL REAL ESTATE BROKERS

PHONE 4382

The Upham Company survived the Depression by selling bonds and insurance and quietly making plans for St. Petersburg Beach. (R. L. Polk.)

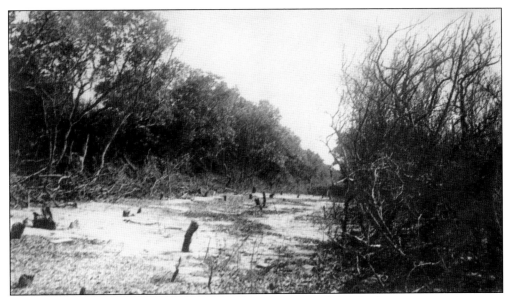

The untamed area just southwest of the Corey Causeway didn't look very impressive then. The Uphams may have been the only ones who imagined it as the perfect place for a town center. (CAU.)

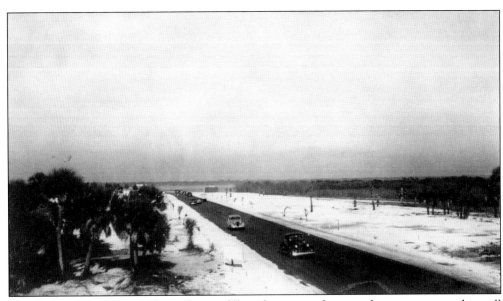

In 1936, they took it upon themselves to fill in the swamp, lie in and pave streets, and install sewers. It was a bold and costly step that eventually paid for itself many times over. (CAU.)

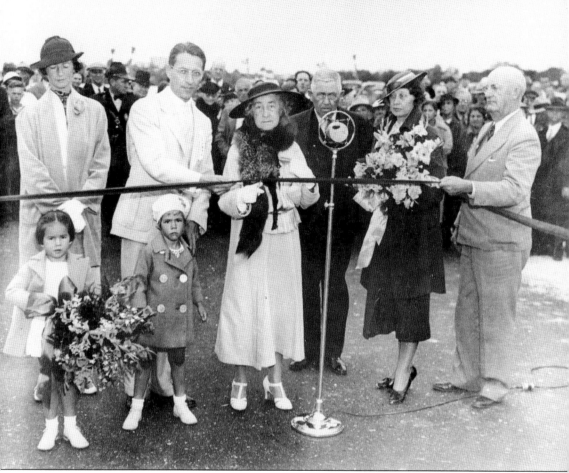

A ribbon-cutting ceremony was scheduled for February 12, 1937, when the Uphams renamed the main boulevard Corey Avenue and turned it over to the county. Niel Upham (in white suit) officiated; Corey's widow, Emma Ware (with flowers), and Blanche Edison, the inventor's daughter-in-law, a winter resident of Treasure Island (wearing stole), were special guests. Also taking part were, from left to right, Mrs. William Upham (Rebekah); William's and Niel's young daughters, Natalie Janeway (left) and Mary Wyatt; H. M. Kiplinger, an Upham Company associate; and Charles R. Carter, chairman of the Pinellas County Commission. (GBHM.)

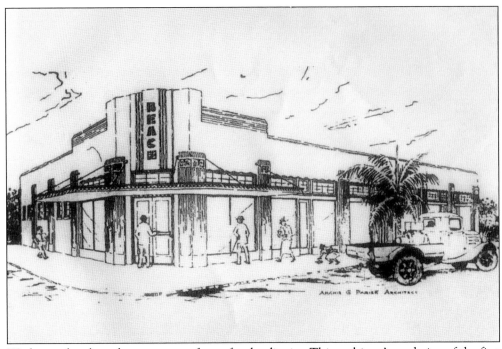

Work was already underway on storefronts for the district. This architect's rendering of the first building was unveiled on the day of the ribbon-cutting. There were more applicants than the storefront could hold, and another was immediately erected. (GBHM.)

It is the intention of The Upham Company, developers of the Corey Avenue, to be in a position to offer a modern, up-to-date store at reasonable rental to any merchant of proven ability and financial strength, who may desire a location on Corey Avenue.

The following businesses are now located on Corey Avenue or adjoining side streets.

Bar and Grille	Meats
Barber Shop	Newspaper
Beauty Parlor	Night Club
Doctor's Office	Painting & Decorating
Drug Supplies	Post Office
Fish Market	Power Company
Funeral Chapel	Printing
Gas Stations (4)	Real Estate
Grocery	Sandwich Shop
Hardware	Theater
Insurance	Water Company Office
Lending Library	Women's Sport Wear

Many new business can be profitably located in this area that are not already there. The following is a list of lines that could be established now or after the war.

Accountant	Laundry
Architect	Marine Ways
Attorney	Milk Station
Bank	Photograph Shop
Bakery	Plumbing
Building Materials	Public Stenographer
Clothing	Pump Sales & Repair
Dentist	Radio Sales & Repair
Department Store	Refrigeration Sales & Repair
Dry Cleaning	Restaurants
Electrical Shop	Roofing
Employment Bureau	Sea Foods
Exterminating Co.	Shoe Store
Five and Ten	Shoe Repair
Flower Shop	Sign Painter
Fruit Store	Taxi Service
Furniture	Tailor Shop
Gift Shop	Tea Room

Developers as much as property owners, the Uphams hoped to quicken Corey Avenue's growth by publishing a wish list for their new downtown. They themselves donated the land and building for a chamber of commerce. (CAU.)

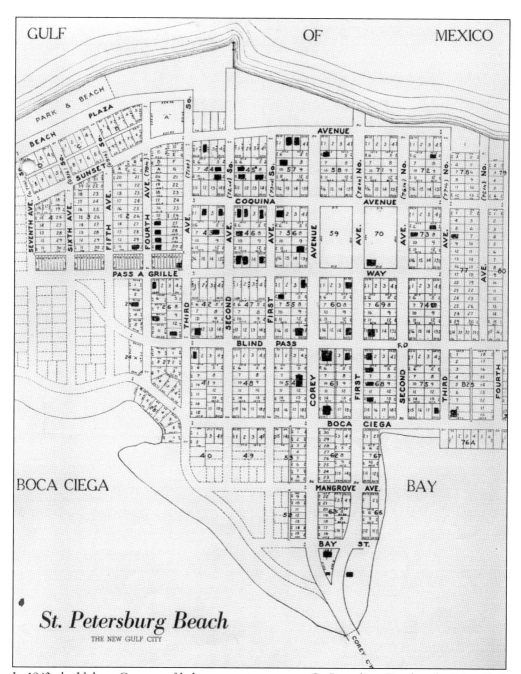

In 1943, the Upham Company filed papers to incorporate St. Petersburg Beach—the "New Gulf City," they called it. William readily accepted the job of mayor. He would become known as the "Father of St. Petersburg Beach." (CAU.)

As soon as St. Petersburg Beach became habitable, William moved his family there. His last home was located among these beautiful waterfront houses on Bay Street, a few blocks south of Corey Avenue. (Tampa-Hillsborough Public Library.)

Nate and Niel always remained in St. Petersburg, in an Upham Company subdivision called Shore Acres. Here Niel and his wife, Rachel, stand outside their residence. (MB.)

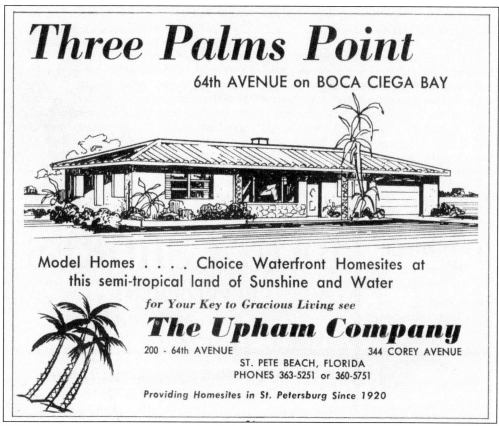
With their business district thriving, the Uphams turned their focus to establishing a residential subdivision in St. Petersburg Beach. Most of the land north and south of Corey Avenue had been zoned non-commercial. A fill off Sixty-fourth Avenue became Three Palms Point. (RLW.)

Until Niel's death in 1959, the Upham Company had maintained two offices, including one on Central Avenue in St. Petersburg. The Upham name can still be seen at the top of the building that contained its last Corey Avenue headquarters. (JSL.)

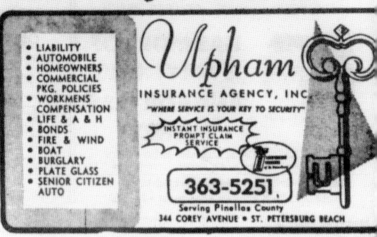
By the late 1960s, William was slowing down, looking forward—he claimed—to retirement. His interests were limited to leasing his business properties and selling all kinds of insurance. (R. L. Polk.)

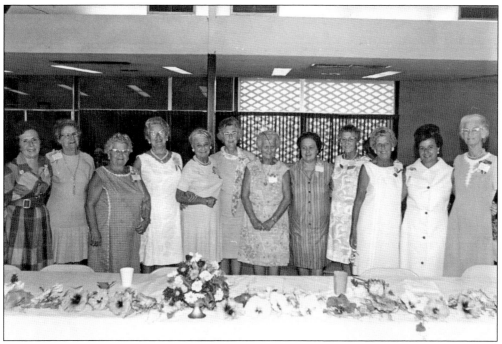

Soon after coming to St. Petersburg Beach, William's wife, Rebekah, joined the Community Club, a service organization of local women. She is on the far right at a 1971 gathering of club presidents. (SPBCC.)

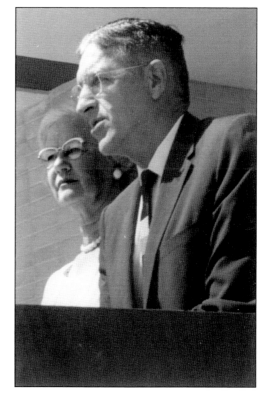

The grandson of a Presbyterian minister, William was active in his church and an early supporter of Florida Presbyterian College in St. Petersburg. In 1964, he and Rebekah appeared together at the dedication of the school's Upham Administration Building. (EC.)

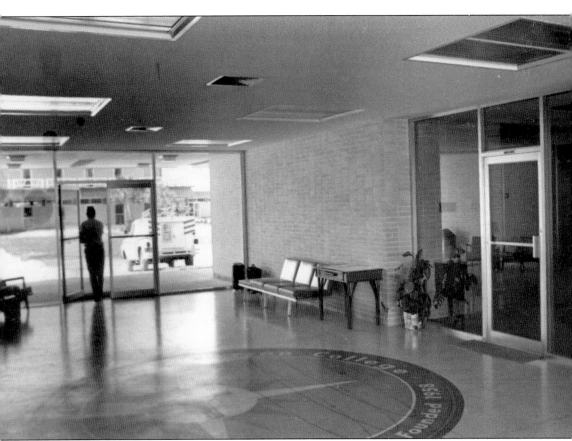

Situated in the center of campus, the Upham Administration Building accommodates the president's suite, the board room, and the offices of the academic deans. (EC.)

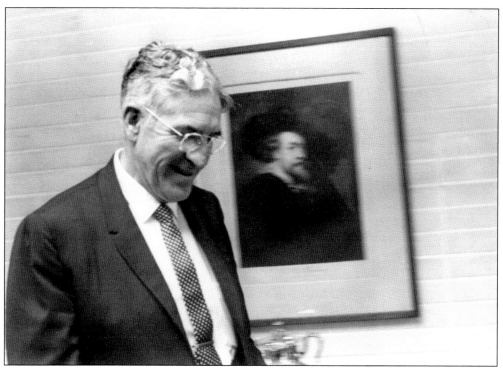

William Upham would serve as a trustee of the college—now known as Eckerd College, in recognition of another benefactor, Jack Eckerd—for much of the rest of his life. (EC.)

The Uphams had reserved their prime Gulf of Mexico property as a beach for residents and their guests. In 1954, the property was turned over to the city of St. Petersburg Beach. (CAU.)

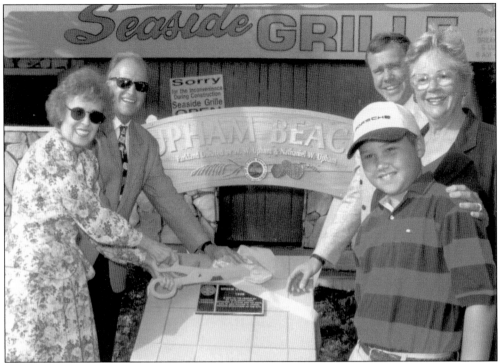

Three Uphams were present when the Honor Walk at Upham Beach was dedicated in 2000—William's widow, Carol (left front); Niel's oldest daughter, Mary Wyatt Allen (right); and Mary Allen's grandson Niel. Nate, Niel, and William were among those remembered in plaques on the walk for their various contributions to St. Petersburg Beach. Also pictured are Jay Anderson, chair of the St. Pete Beach Historic Preservation Board (left) and Ward Friszolowski, St. Pete Beach mayor. (GBHM.)

William remarried after Rebekah's passing. Carol Ann Upham is a photographer who, in 1986, opened the Upham Gallery on Corey Avenue. In 1997, Carol became president of the St. Petersburg Museum of Fine Arts. She continues to live on St. Pete Beach. (SPT.)

Three

FIRST ARRIVALS

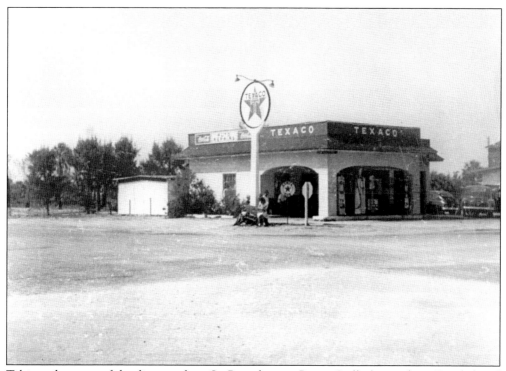

Taking advantage of the distance from St. Petersburg to Pass-a-Grille (as much as 10 miles) and the possible need to refuel, gas stations were among the earliest businesses established in the area. (GBHM.)

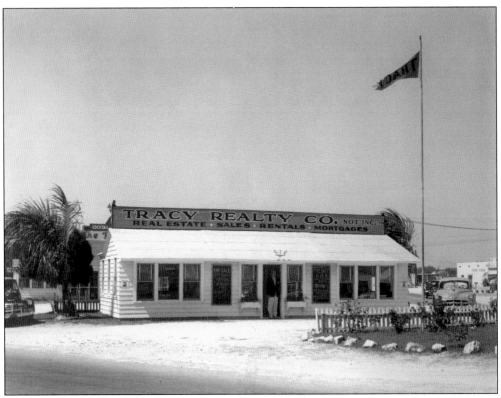

In case someone wanted to buy property in Pass-a-Grille, a real estate agent was strategically positioned on the south side of the Corey bridge. (GBHM.)

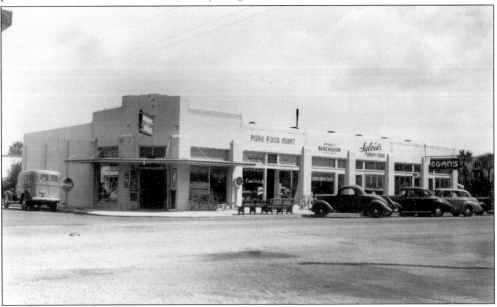

The Upham Company had a storefront ready for occupancy a few months after their splashy dedication in February 1937. The structure still stands, after many renovations, on the northeast corner of Corey Avenue and Blind Pass Road. (GBHM.)

The first grocer on Treasure Island, Harry Schuster, became one of the first merchants on Corey Avenue when he moved his business to the just-completed building. Weekly specials were posted in the windows. (PS.)

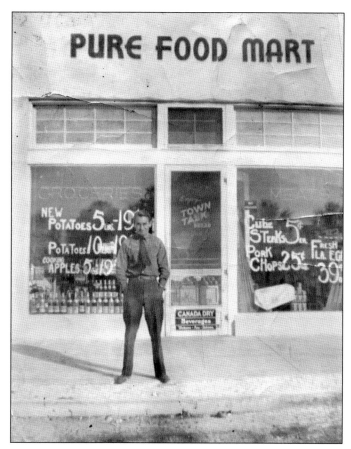

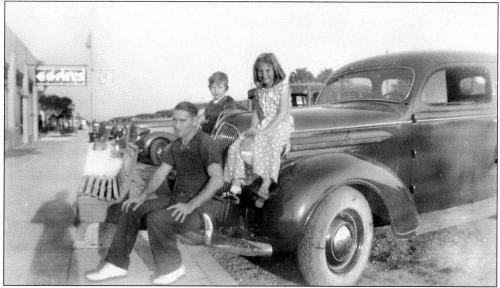

For many years, the Schuster family lived right on Corey Avenue, in an apartment above a storefront farther down the street. Daughter Phyllis and son Irwin are pictured here with their dad, Harry. (PS.)

Following World War II, Harry partnered with his cousin Aaron Silverman to open Schuster's Menswear in the same location. (NPL.)

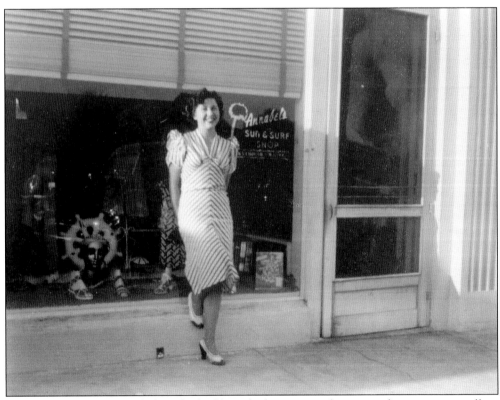

Harry's sister-in-law, Annabel Jacobs, had been looking to turn her years of experience in selling women's apparel into a store of her own. She set up Annabel's Sun and Surf Shop next to the Pure Food Mart. (PS.)

An attractive, single young woman, Annabel modeled many of the items she sold. She specialized in comfortable outfits for the beach—especially shorts. (PS.)

Annabel got her name out by joining the chamber of commerce, supplying clothes for hotel fashion shows, and advertising regularly in the local newspapers. (BK.)

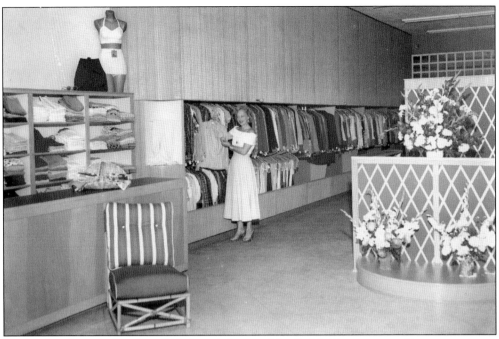

The hard work paid off, and in 1948, Annabel—now Mrs. Ralph Carson—was able to rent a larger space in the same block, with fixtures and decor she had designed herself. Here sales assistant Winnie Feldhusen shows off the striking interior. (BK.)

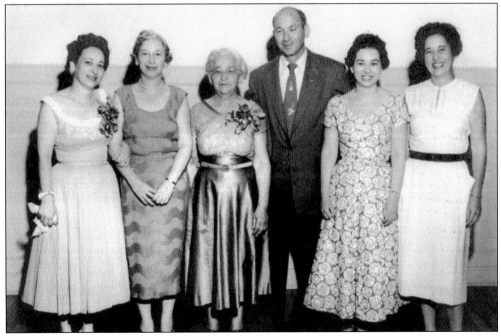

Including Annabel (far right) there were, in all, four Jacobs daughters—three of whom became retailers on Corey Avenue. Jean (far left) had Jean's Costume Jewelry, later Jean's Handbags. Goldie (second from left), Harry Schuster's wife, had Toddlers to Teens dress store and, following Harry's death in 1955, Schuster's Menswear. (PS.)

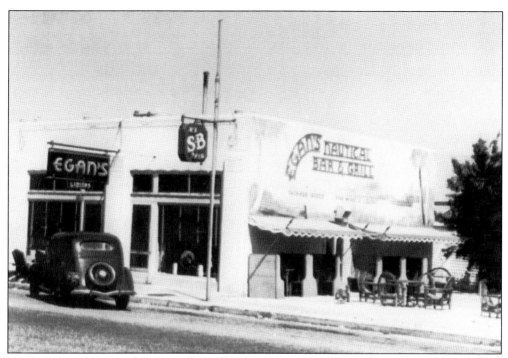

Joe Eagan was the owner/operator of a small café in downtown St. Petersburg when he heard about all the activity on Corey Avenue. Knowing he could do better, the veteran chef and restaurant manager applied to the Uphams for a place in their building. It was at this time that a sign painter dropped the first "a" in Eagan; the name stuck. (GBHM.)

Joe and his wife, Jeannette, had come to St. Petersburg from New York in 1925 on their honeymoon. Both quickly found employment at the brand-new Derby Lane greyhound track—he in the clubhouse kitchen, she breeding and training dogs. Over the years, Jeannette Eagan produced many winners. Of course, racing programs were always available at Egan's. (Louise Weaver.)

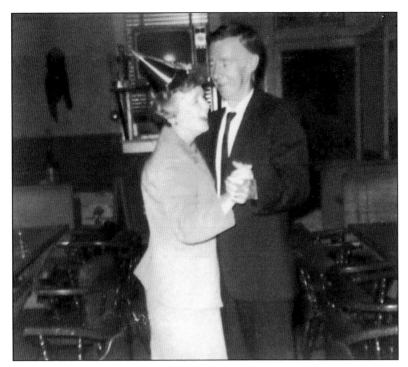

Egan's Nautical Bar and Grille soon became a favorite spot for famous sports figures like the baseball players who spent the early spring training in St. Petersburg. But locals liked it, too. Here John and Julia Mulhearn of Pass-a-Grille celebrate New Year's Eve at Egan's. (George and Jeanne Crane.)

The cage of the Eagans' yellow-tailed talking parrot, Barnacle Bill, often sat outside the restaurant on Corey Avenue. (GBHM.)

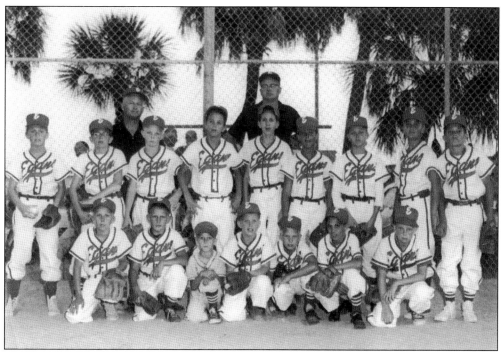

Sports fans themselves, the Eagans may be best remembered for getting Little League going on the Gulf Beaches. In fact, it was one of the first franchises in the nation. The baseball field at the north end of St. Pete Beach is named for them. (GBHM.)

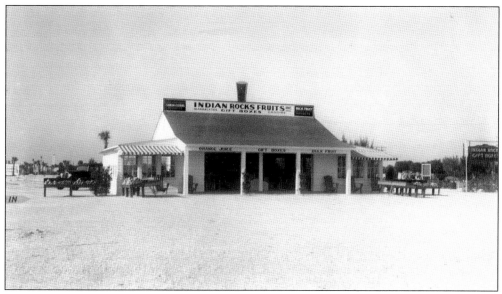

The Indian Rocks Fruit Company chose this site in December 1937 at the west end of the Corey Causeway for a gift store outlet. (CAU.)

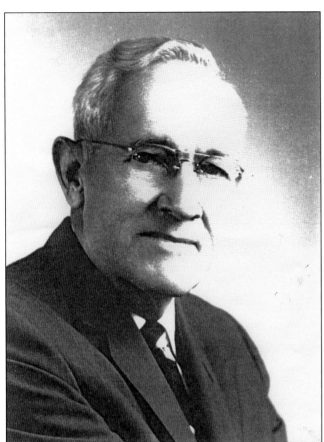

Lawrence Baynard was another successful St. Petersburg businessman who early on recognized an opportunity on Corey Avenue. (Barbara Hubble.)

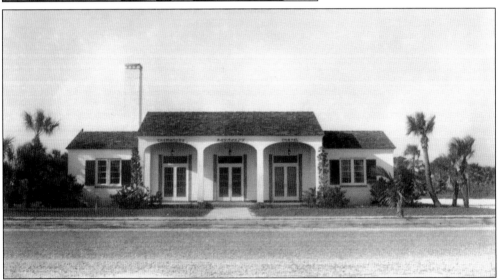

An investor, later banker, and member of a well-connected family, Baynard erected a funeral home and crematory on a large lot he had purchased from the Upham Company, on Corey Avenue and Boca Ciega Drive. Constructed in mid-1937, the crematory was the first of its kind in Pinellas County. (CAU.)

Professional mortician Paul Thompson arrived in the summer of 1949, adding ambulance services—and eventually his name—to Baynard's Funeral Home. (NPL.)

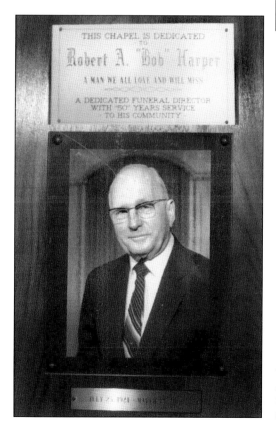

In 2001, the chapel room of the funeral home was dedicated to Robert A. Harper, a beloved St. Petersburg native who had served as funeral director from 1958 to 1996. (JSL.)

47

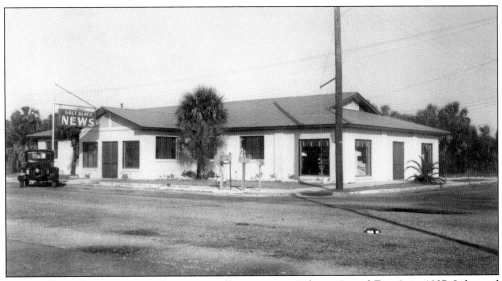

The *Gulf Beach News* put up this roomy office opposite Schuster's and Egan's in 1937. It hosted many civic meetings before the Community Club house was built. (GBHM.)

Founded in 1934, the eight-page weekly *Gulf Beach News* combined information on island happenings with unique feature stories. Pioneer Pinellas developer Walter Fuller was a frequent contributor. Its run ended in February 1951. (RLW.)

To make communication and bill paying more convenient for their island customers, the Florida Power Corporation (FPC) opened a beach branch in a section of the *News* building in August 1939. (GBHM.)

By the mid-1950s, the population of the Pinellas beaches had increased tenfold. Many more homes needed electricity. This new FPC office on Seventy-fifth Avenue held the records for all those residents, as well as a demonstration kitchen and lecture hall. (GBHM.)

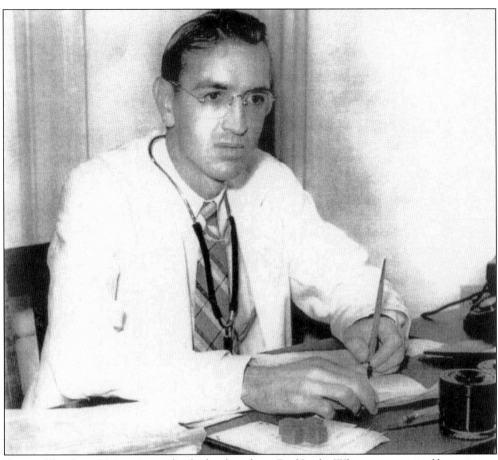

Recent Ohio State University medical school graduate Paul Leslie White was recruited by a citizens committee in 1938 to establish a practice in St. Petersburg Beach. Before that time, residents had to travel all the way to St. Petersburg—and farther—for their health care. (GBHM.)

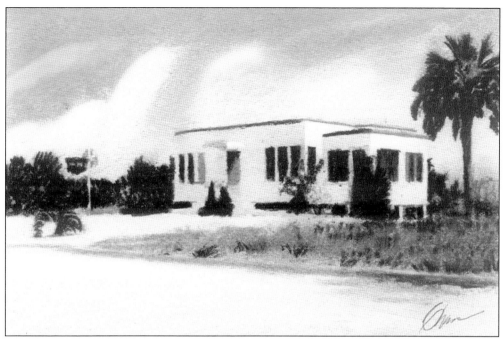

White's original office was also his home—a small wooden-framed cottage on sandy Corey Avenue, just west of Gulf Boulevard. Paul and his wife, Bea, slept in the screened-in porch, and the one refrigerator in the house was used for storing laboratory specimens as well as the couple's food. (GC.)

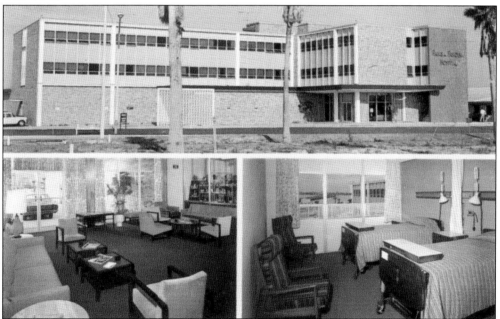

Recognizing the need for a mid-level care facility closer to the beaches, White joined with several other doctors in purchasing a group of cottages just over the Corey bridge for that purpose. The cottages evolved into the Palms of Pasadena Nursing Center, which within a few years became the Palms of Pasadena Hospital. (RLW.)

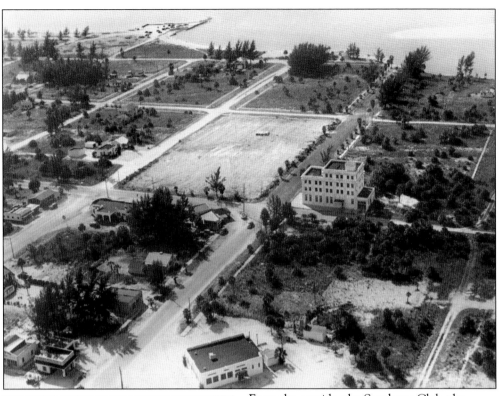

From the outside, the Sundown Club, the first nightclub on the beaches, was not much to look at. The single-story square cement structure had been erected around 1934 on a graveled lot at Blind Pass Road not far from William McAdoo's 1920s monolith. (GBHM.)

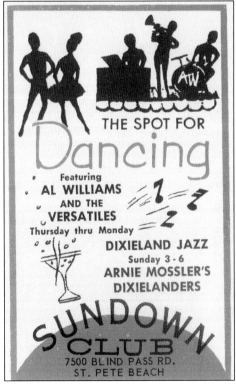

THE SPOT FOR
Dancing
Featuring
AL WILLIAMS
AND THE
VERSATILES
Thursday thru Monday
DIXIELAND JAZZ
Sunday 3 - 6
ARNIE MOSSLER'S
DIXIELANDERS
SUNDOWN CLUB
7500 BLIND PASS RD.
ST. PETE BEACH

Inside, though, things were hopping. In the beginning, big band sounds were often heard. Later, comedians like Martha Raye and Ann Davis made appearances. During World War II, the Sundown was prescribed as R&R for servicemen billeted at the Don Ce-sar Government Hospital. (RLW.)

Four

THE BEACH THEATRE

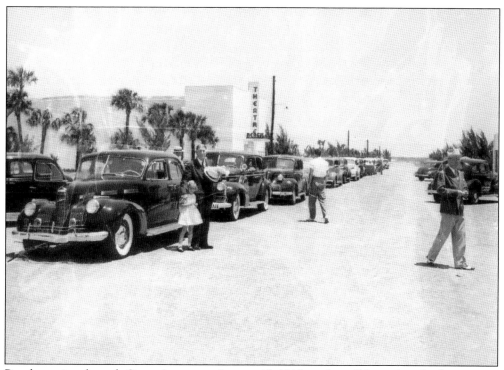

People passing through Corey Avenue on January 15, 1940, might well have thought they were in the midst of a Hollywood premiere. Even developer William Upham and his niece Mary Wyatt look impressed as they arrive for the very first show at the new Beach Theatre. (SPMOH.)

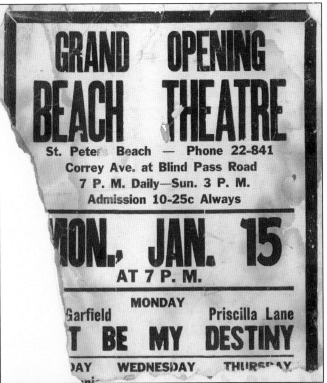

An original playbill advertising the event has been handed down from owner to owner. The printer must not have been familiar with Corey Avenue. (MF.)

The feature that night was *Dust Be My Destiny*, with rising star John Garfield and Priscilla Lane, his frequent leading lady. Garfield performed the part of a misfit who ends up on a chain gang and falls in love with the foreman's daughter. (Corbis.)

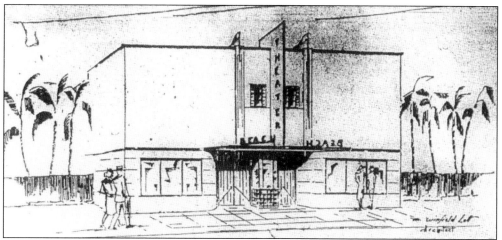

Local young architect Winfield Lott was engaged to design the movie house. Stephen Girard, a successful Boston haberdasher with a love for films and a winter home on Long Key, financed it—reportedly for $50,000, many times the cost of any other building on the street. It boasted 528 seats, air-conditioning, and a state-of-the-art sound system. (RLW.)

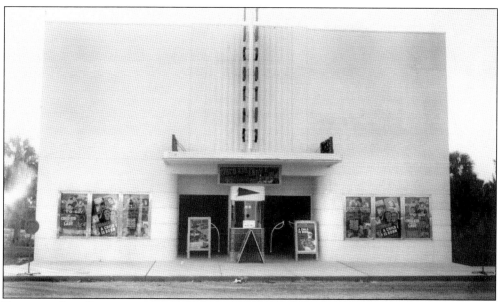

For years, the offerings were second-runs that had already played in St. Petersburg. A regular schedule was curtailed for 18 months during World War II by an evening curfew brought on by the sighting of a German U-boat offshore. (CAU.)

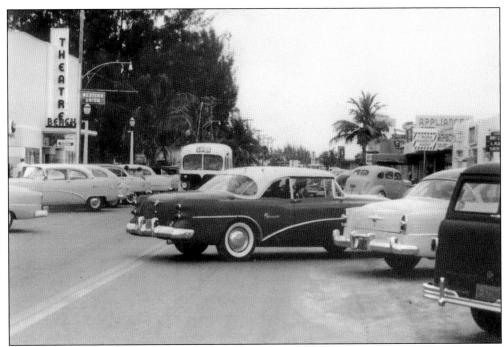

The theater—and Corey Avenue—really came to life in the 1950s. Under the ownership of Frederick Van Doren, there were shows every night, even in the summer. Dorothy Van Doren, Frederick's wife, was famous for breaking up misbehaving teens with the glare of her flashlight. (SPT.)

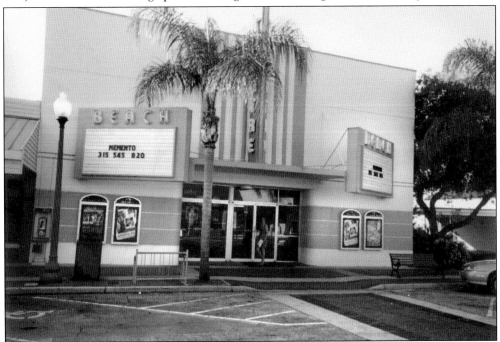

Competition from a brand-new ultra-modern movie house in the Dolphin Village Shopping Center on Gulf Boulevard precipitated several enhancements in 1970, including the installation of two large outdoor marquees. (Susan Ryan.)

In 1985, the theater—as well as the funeral home next door—were used for two of the scenes in the John Candy comedy *Summer Rental*, then filming all over the Pinellas beaches. Here director Carl Reiner confers with actress Karen Austin right on Corey Avenue. (EF.)

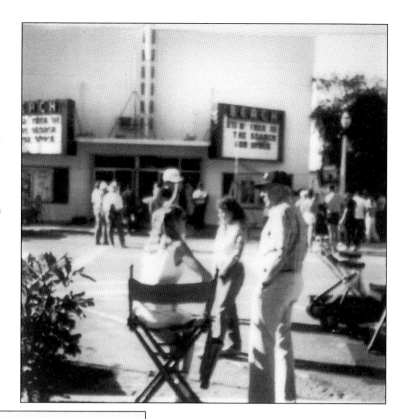

```
                         BOBBY
            Yeah, can we go?  Can we go?

                         SANDY
            Absolutely.
                    (a beat)
            Oh, wait a minute.  Kids, we
            can't... Daddy can't go out with
            his bad leg.

They all frown.

                         JACK
                    (cutting in)
            No, no, don't be silly.  You all
            go and have a good time.  I'll
            stay home.

                         BOBBY/LAURIE
                    (leaping up and down)
            Yaaaay!  Yaaaay!

CUT TO:

Outside the house.  Buckets of rain are pouring down on
the roof with a vengeance.

Through the streaked upstairs window, we see Jack sitting
on his bed.

CUT TO:

Inside.  Jack painstakingly working on a boat-in-a-bottle.
He's in a bathrobe.  A pillow is propped under his leg.

Suddenly -- BLIP, BLIP, BLIP.  A leak starts hitting the
bed.  Jack, annoyed, hobbles off bed, gets wastebasket,
places it on bed.  He continues to work on his boat, but
is distracted by sound of water filling wastebasket --
TINK, TINK, TINK, TINK...

CUT TO:

Outside the local movie theater.  Sandy and kids at the
end of a line of five hundred people who had the same
idea.  The family is pressed against side of building,
trying to shield themselves from driving rain.  Some late
arrivals get behind them, a man and a teenage girl.
Jennifer recognizes the girl.
```

One part of the script called for the family making the best of a rainy day by going to a movie while Candy, as Jack Chester, stayed back at their leased cottage. (RLW.)

Shell Wimpfen owned the theater intermittently for more than 20 years, beginning in 1972. An art cinema aficionado, he brought in quality independents and imports he discovered at film festivals. Shell's wife, Carmen, frequently assisted at the snack bar. (TT.)

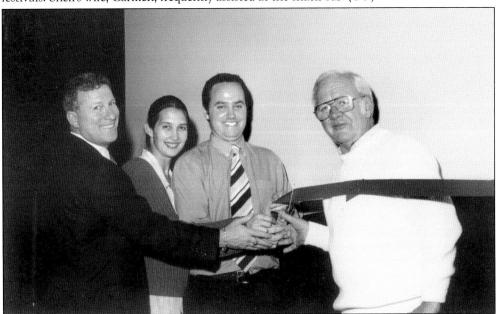

In 1997, international commodities trader Raza Chouls purchased the theater from Wimpfen and turned it over to his daughter and new son-in-law, Joanna and Richard Hughes, to operate. The Hughes renamed it Film Paradiso and secured a liquor license in order to serve beer and wine. Corey Area Merchants Association president Lornie Mueller and St. Pete Beach mayor Ron McKenney helped the couple celebrate a major refurbishment in fall 1999. (GBHM.)

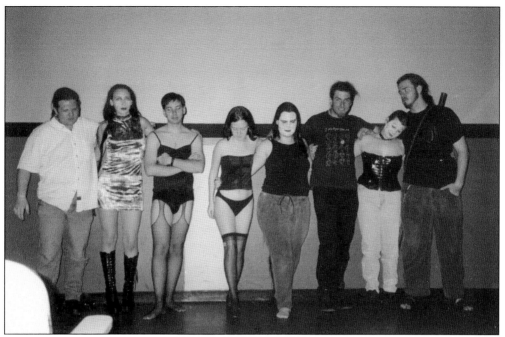

Late Saturday nights on Corey Avenue changed significantly when a live cast of *The Rocky Horror Picture Show* took to the Beach Theatre stage on June 17, 2000. The presentation by Tampa Bay acting troupe Interchangeable Parts continues weekly. (Interchangeable Parts.)

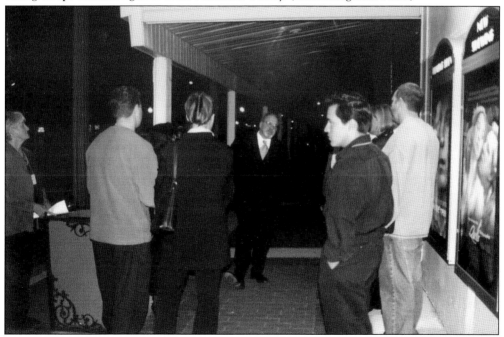

No one in St. Pete Beach had seen *Forever Mine*, a romantic thriller shot at the Don Ce-sar Hotel in 1999, until the Pinellas Film Commission hosted a special screening at the Beach Theatre early the next year. Director Paul Schrader, seen here greeting members of the audience, introduced the movie and answered questions. (Pinellas Film Commission.)

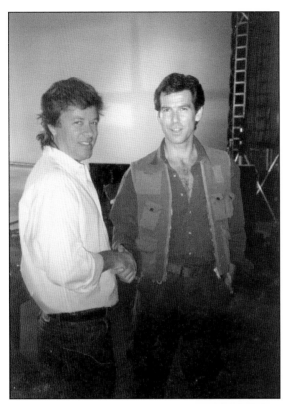

Eventually the Chouls, wanting to return to their native England, put the theater up for sale. Area film buffs were worried, but it was quickly bought by screenwriter Michael France, a resident of Pass-a-Grille. France had created the original story for the first Pierce Brosnan James Bond film, *Goldeneye*. (MF.)

France's first bookings were *The Wizard of Oz* and *His Girl Friday*, popular movies from 1939, the year the Beach Theatre was built. (MF.)

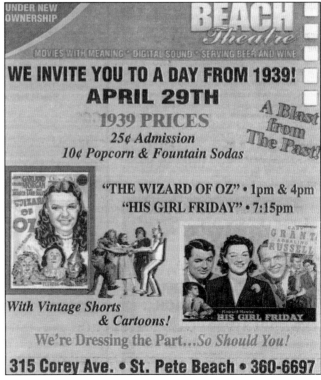

Five

THE POSTWAR BOOM

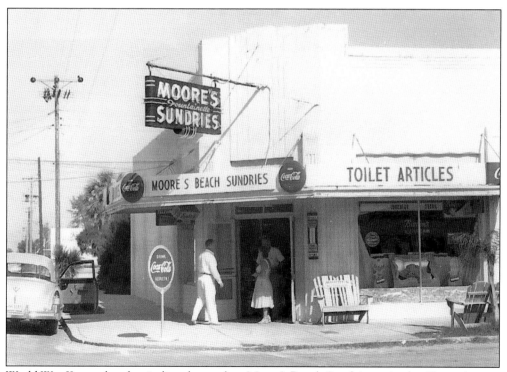
World War II was already winding down when Moore's Beach Sundries arrived at Corey Avenue and Blind Pass Road, replacing a McKinnon's Pharmacy branch. (BH.)

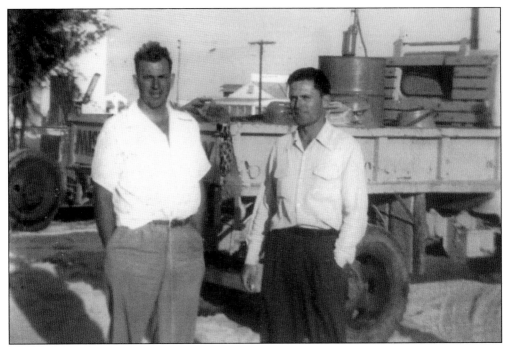

Richard Misener left high school in order to build seawalls for the Upham Company. In 1947, he invited his boating buddy Carle McEvoy (right) to help him start a marine construction firm. (GBHM.)

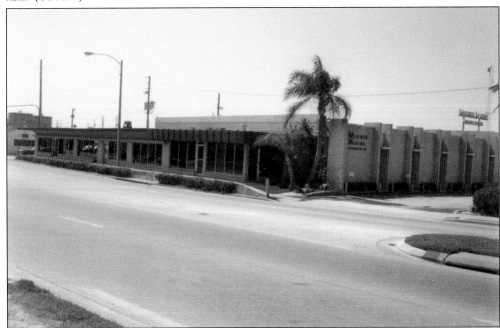

Not surprisingly, the demand for seawalls, as well as docks and pools, in the waterfront city was overwhelming. By 1950, Misener and McEvoy had 20 staff members, five trucks, two barges, and a towboat—enough to warrant their own office and manufacturing plant, located on Seventy-fifth Avenue near the Corey bridge. (COSPB.)

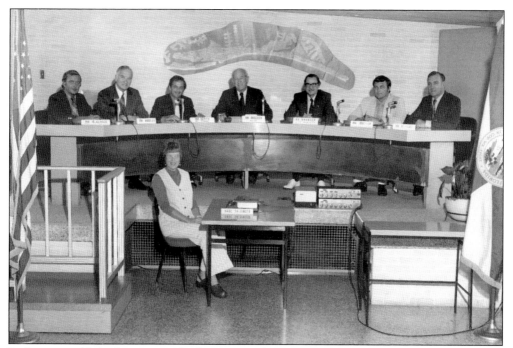

Both men would also become involved in St. Petersburg Beach politics—McEvoy as a commissioner and Misener as commissioner and mayor. Here Misener (center) presides over a 1971 city meeting. (GBHM.)

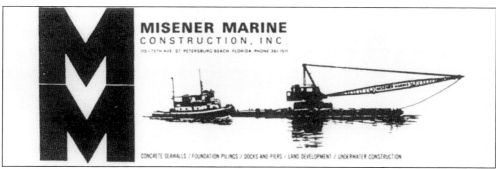

In the mid-1960s, McEvoy sold his interest in the company and moved to San Diego to concentrate on his lifelong passion of sailing. Misener Marine continued to grow—too big, in fact, for St. Petersburg Beach. By 1981, it had relocated to Tampa. The Seven-Mile Bridge to the Florida Keys, completed the next year, was one of Misener Marine's biggest projects. (RLW.)

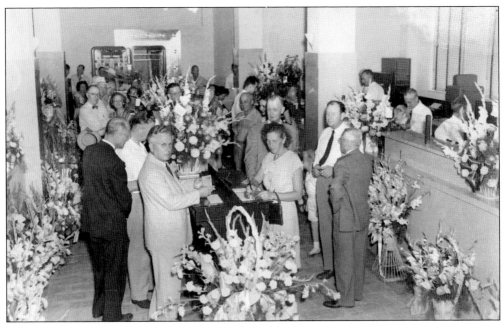

The Corey area's biggest financial boost came on July 29, 1948, the official launch date of the First Gulf Beach Bank. Residents and merchants, anxious for neighborhood convenience, hurried in to open or transfer accounts. (MB.)

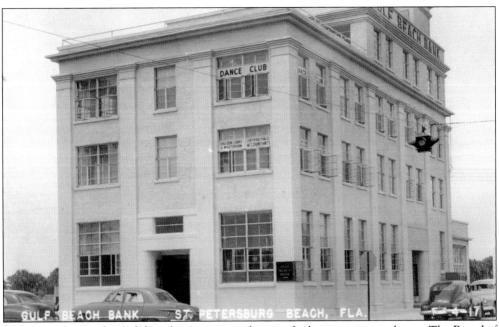

One thing the new bank did not have to worry about at the beginning was a home. The Board of Directors bought developer William McAdoo's five-story, fireproof "personal vault," at Seventy-fifth Avenue and Gulf Boulevard, vacant for nearly 25 years. (GBHM.)

Founders of the bank were state senator Henry S. Baynard and state hotel commissioner J. Lee Ballard, seen here with his longtime secretary, Pauline Goeppel. Ballard remained with the financial institution until it was sold in 1977 to Ellis Banks of Florida. (MB.)

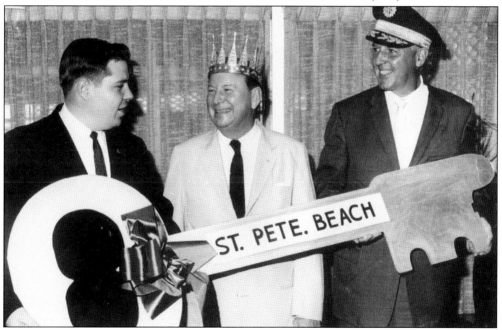

For bank president and CEO Ballard, civic activities were as important as business. In 1962, he was honored for his community works by being named the Festival of States' "Mr. Sun." St. Petersburg Beach mayor Grover Criswell (left) followed suit, presenting Ballard with a well-deserved key to the city. Pictured on the right is Wilson Hubbard, St. Petersburg Beach Chamber of Commerce president. (COSPB.)

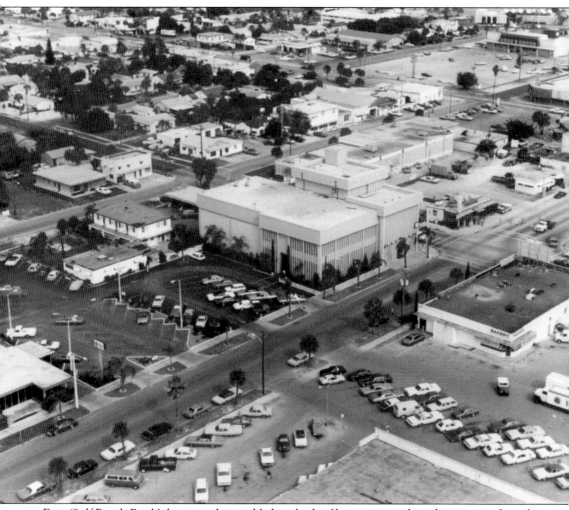

First Gulf Beach Bank's loans made possible hundreds of businesses and residences, significantly contributing to the growth of St. Petersburg Beach. In 1971, that success warranted a larger bank building. The two-story addition nearly doubled the bank's size. (MB.)

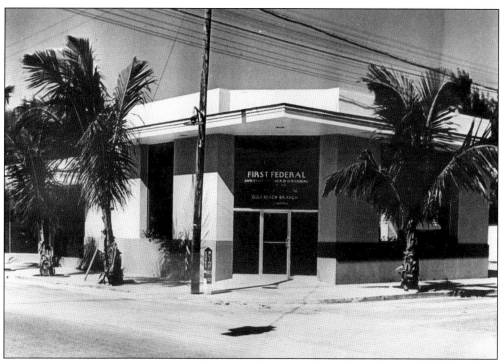

In 1949, ready to expand its operations, First Federal Savings of St. Petersburg looked to burgeoning St. Petersburg Beach. This was First Federal's first-ever branch, the seed of what would eventually become a statewide banking empire. (GBHM.)

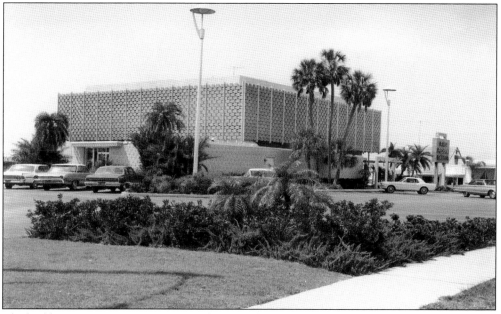

The building at 401 Corey Avenue soon became obsolete. Customers wanted, at the least, a drive-through window and ample, off-street parking. By 1963, First Federal had purchased the large, half-block lot on the opposite side of Corey Avenue and erected the modern, 12,000-square-foot facility seen here. (GBHM.)

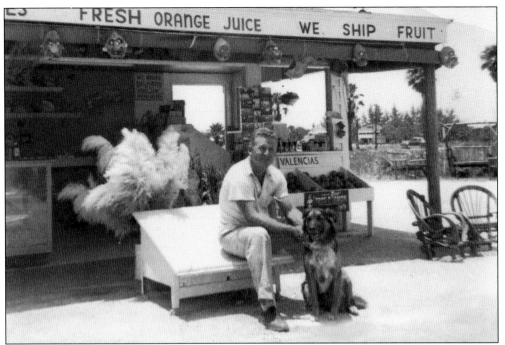

After four years of college and a stint in the navy during World War II, Ted Stambaugh headed for St. Petersburg Beach to join his father, William R. "Cousin Billy" Stambaugh, a well-known area entrepreneur, in the real estate business. (GBHM.)

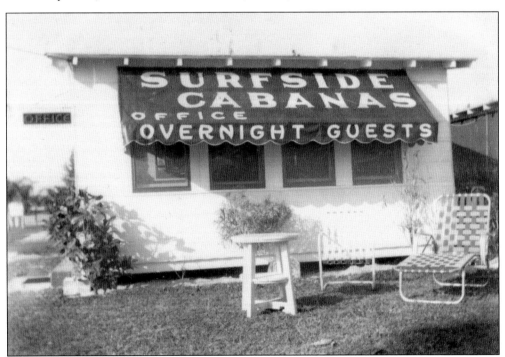

Among the Stambaughs' properties was Surfside Cabanas at Corey Avenue and Coquina Way. It was razed in 1959 for a shopping center, anchored then by a Winn-Dixie supermarket. (GBHM.)

Ted made a name for himself by entering local politics. He served as St. Petersburg Beach commissioner, mayor, and even police commissioner. However, he is best remembered for bringing the London Wax Museum to town. (GBHM.)

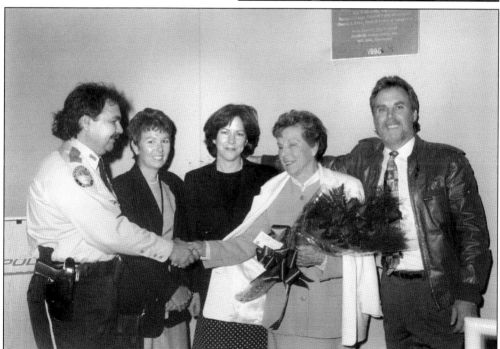

Stambaugh's wife, Althea, and children—Holly (left), Patty, and Rob—were present for the dedication of St. Petersburg Beach's Ted Stambaugh Police Station in 1995. (GBHM.)

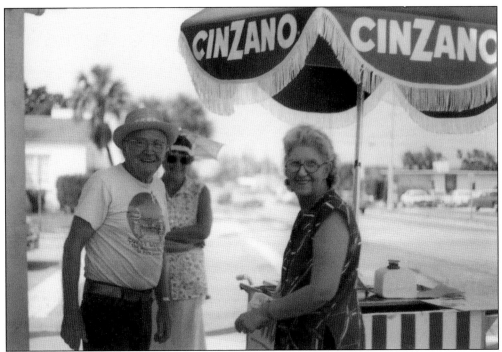

Bill Zeiler had been employed by the McClellan variety chain since high school. The Illinois native learned of the opportunities in St. Petersburg Beach through his in-laws back in Florida. He and his wife, Betty (not pictured), established the Corey Avenue 5&10 in 1949. Here Zeiler takes part in a Corey Avenue sidewalk sale. (GBHM.)

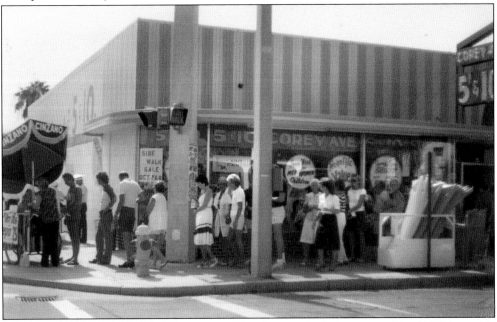

Zeiler's dime store soon became known as "the place to find almost anything." With a wide green-and-white striped cornice, big glass display windows, and a giant cutout sign attached to the outside top, it was easy to spot. (RLW.)

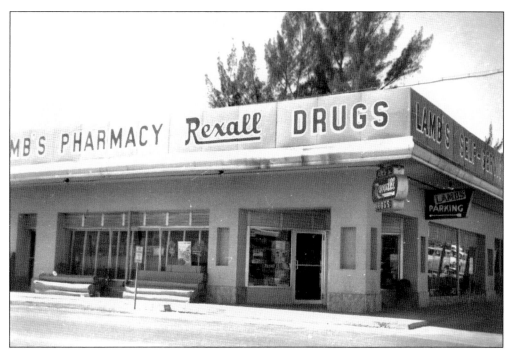

In St. Petersburg Beach, Robert Lamb realized his dream of owning an old-fashioned drugstore. The young pharmacist from Webster, Florida, was only one year out of the University of Florida when he leased a space at Blind Pass Road and Seventy-fifth Avenue in 1949. (RLW.)

Lamb's customers would frequently refer to him as "Doc" for the medical advice that came with the prescriptions he filled. Coffee breaks were spent at the soda fountain in the company of many of the movers and shakers of the Corey area. (RLW.)

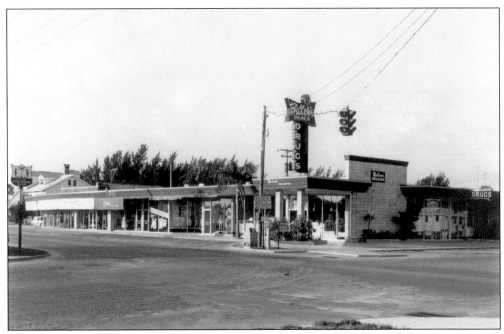

Carl Baker proved there was room in St. Petersburg Beach for more than one drugstore. Baker's Beach Pharmacy, at 7340 Gulf Boulevard, employed a cosmetics specialist and the first female pharmacist in town. (GBHM.)

Charles Walker, a chemical engineer with Murphy Paints, purchased Gulf Beach Paint and Hardware Center in 1950. The store, a real family business, would become part of the Ace Hardware franchise 13 years later. Charlie (center, right) was assisted by his brother Vic (far right) and his wife, Cindy. (Elaine Tyska.)

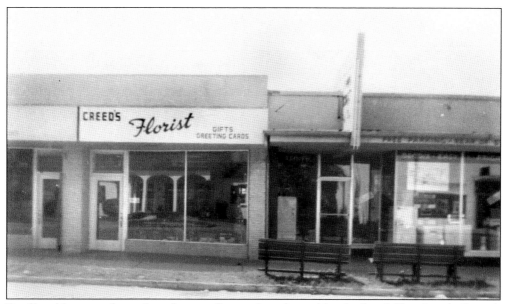

Peg Creed knew nothing about being a florist when she and her husband, Ken, bought Bessie's Flowers at 316 Corey Avenue in 1954. The Pennsylvania couple, who had moved to Florida on doctor's orders to find a warmer climate for Ken, was simply looking for a steady income. The business closed in 1960 when Ken, an engineer, found a job at the new Pinellas General Electric plant. (Peg Creed.)

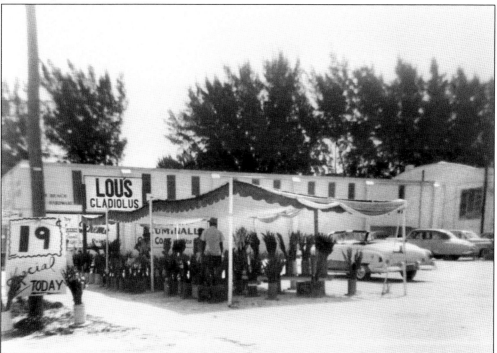

Lou Lovell's normal job was hauling produce. During slack times, he transported gladiolas and sold them out of the back of his truck. In 1956, he stopped traveling long enough to start Lou's Florist on Seventy-fifth Avenue. (GBHM.)

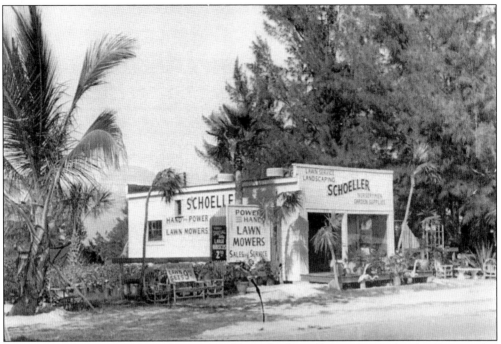

John Schoeller worked nights as a waiter and happily clipped lawns during the day. By 1949, his interest in gardening had evolved into a successful business, the first nursery on the beaches. His property, at 250 Corey Avenue, was leased from developer William Upham. (Roger Prinse.)

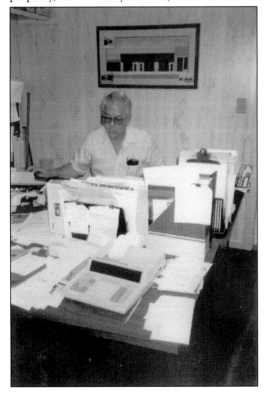

George Reardon sold his Corey Avenue office supply business in 1964, but it continued to carry his name for the next 25 years. Here Joe Franko, one of the subsequent owners, reviews accounts in 1981. (EF.)

There was no optometrist on St. Petersburg Beach until Dr. William Murrell set up an office on Corey Avenue in March 1949. An Air Force reservist, he had to suspend his practice when he was called to serve in the Korean War. (Peggy Murrell.)

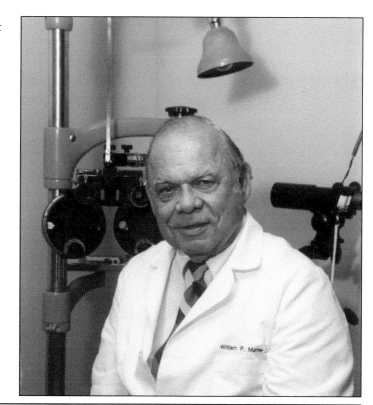

Upon his return, Murrell and his family settled on Boca Ciega Isle. Robert Cole, a dentist with this office and lab on Seventy-fifth Avenue, was a neighbor. The two would eventually share a building on Seventy-sixth Avenue. (Jodi Eaton.)

You Are Cordially Invited

TO ATTEND

Bible School . . . 10 A. M.

Worship Service . . 11 A. M.

Sermon Subject:
"Christian Discipleship"

St. Petersburg Beach Baptist Chapel

St. Petersburg Beach Community Club Building

(Temporary Home)

(C. R. Murphy, Interim Pastor)

The First Baptist Church of St. Petersburg Beach was a mission of the First Baptist Church of St. Petersburg. To test the interest of possible island parishioners, worship services and Sunday school classes were held in the Community Club house in 1949. (NPL.)

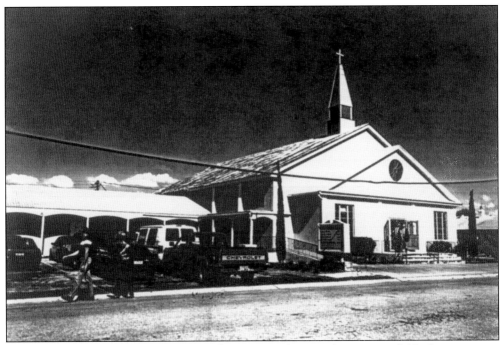

By the next year, construction was underway on a large auditorium and 10 classrooms on three lots at Seventy-third Avenue and Boca Ciega Drive. The main church sanctuary was added later. (GBHM.)

Six

CITY OPERATIONS

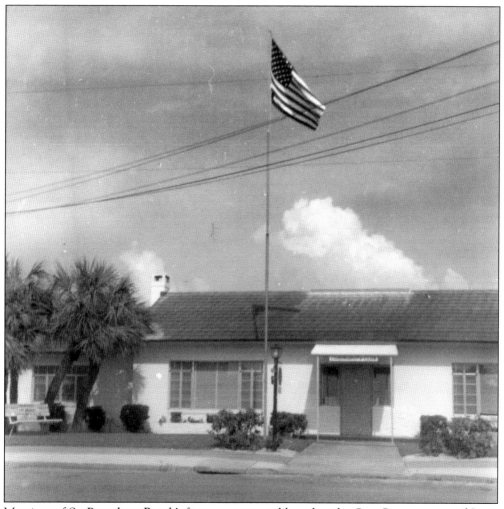

Meetings of St. Petersburg Beach's first governmental boards—the City Commission and Long Key Sewer District—were held at the Community Club house at 7301 Blind Pass Road, just south of Corey Avenue. (SPBCC.)

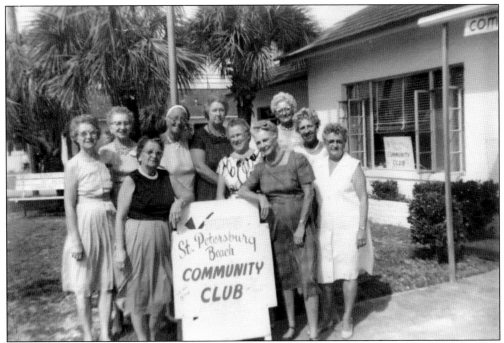

The Community Club had been organized in the 1930s to provide "recreational" activities for beach residents. City governments eventually assumed responsibility for many of their programs, including St. Pete Beach's public library. (SPBCC.)

Originally set up in a corner of the Community Club in 1951, the Long Key Library became so popular that it had to be moved into an addition just four years later. Somehow, the club also found space in its building for the offices of the city clerk, the city attorney, the mayor, and the police chief. (GBHM.)

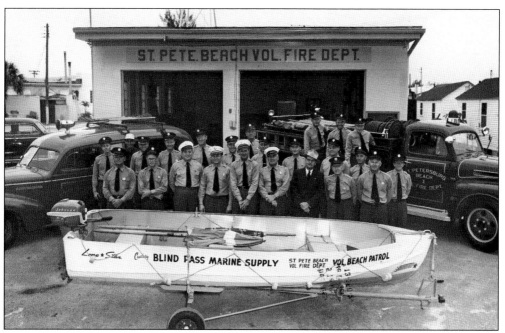

When a blaze damaged three stores on Corey Avenue in May 1950, a volunteer fire department was quickly put together. The St. Petersburg Beach police chief, a former firefighter, trained the 20 men who signed up, many of whom were Corey area businessmen. The firehouse was located at 420 Seventy-sixth Avenue. (GBHM.)

Construction of a municipal auditorium near the Corey Causeway had already started when the four towns of Long Key voted to merge into one on July 9, 1957. The new commission immediately turned the previously funded project into a much more needed city hall. (COSPB.)

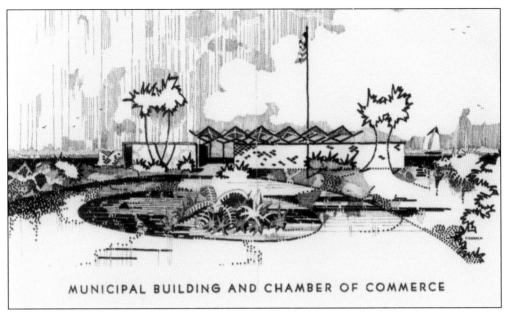

MUNICIPAL BUILDING AND CHAMBER OF COMMERCE

Designed by St. Petersburg architects William B. Harvard and B. E. Jolly, the modernistic complex on Boca Ciega Bay featured the chamber of commerce and police department on one side, and government offices and a dual commission/courtroom on the other. (COSPB.)

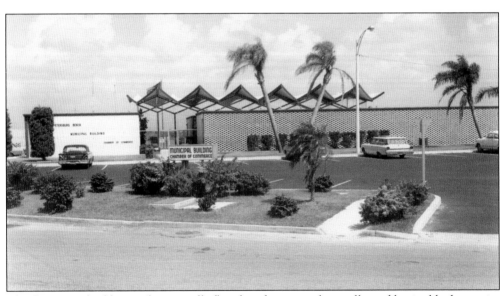

The distinctive building with a partially fluted roof, interior glass walls, and lattice block exterior earned an Award of Merit from the American Institute of Architects. City staff moved in on December 10, 1958. (COSPB.)

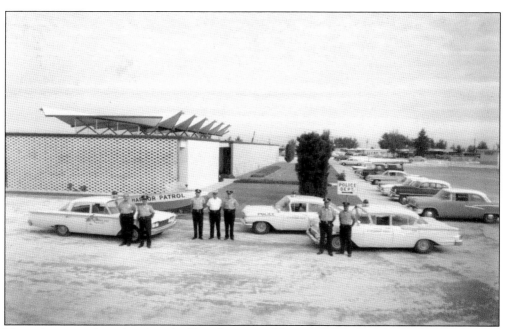

Up to that time, the police force had largely operated from its cruisers on the road. Officers stand proudly in front of their first real headquarters. (COSPB.)

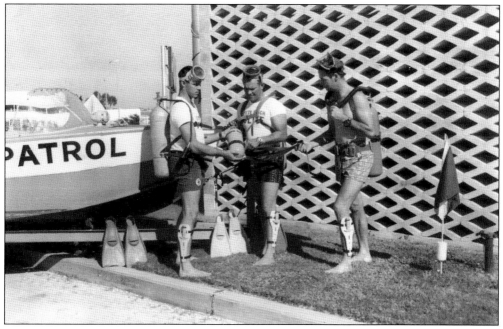

Responsible for protecting an island community with more than 20 miles of coastline, police could be called on to patrol from the water, too. (COSPB.)

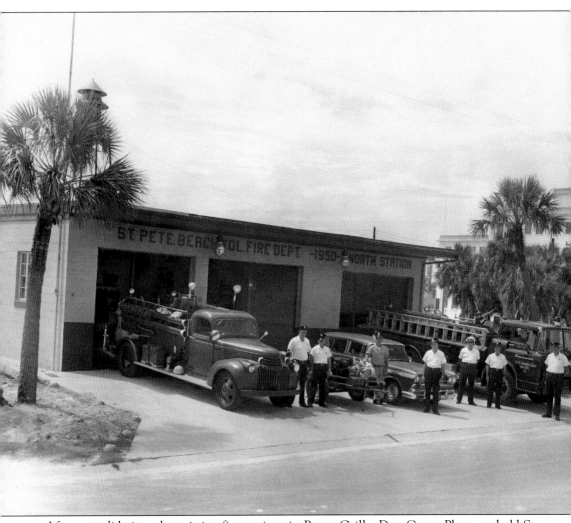

After consolidation, the existing fire stations in Pass-a-Grille, Don Ce-sar Place, and old St. Petersburg Beach were all retained and designated "South," "Central," and "North," respectively. A fire chief was employed to supervise the large force of city-wide volunteers. (GBHM.)

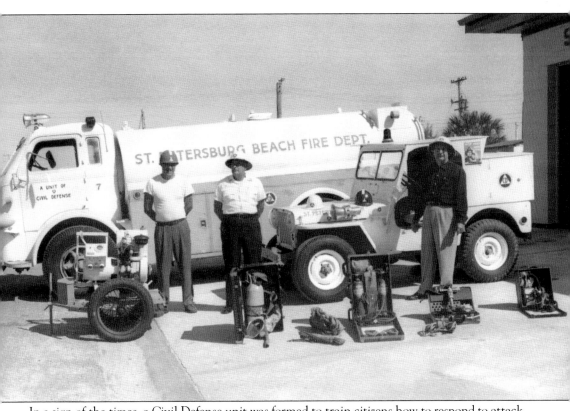

In a sign of the times, a Civil Defense unit was formed to train citizens how to respond to attack warnings. Missiles were expected to be launched on the Tampa Bay area, home to MacDill Air Force Base, from communist Cuba. (COSPB.)

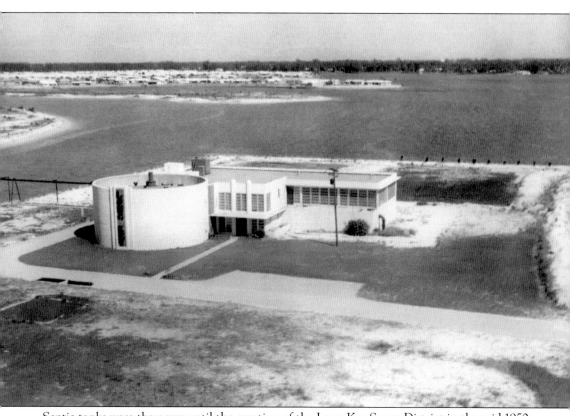

Septic tanks were the norm until the creation of the Long Key Sewer District in the mid-1950s. Of course, no one wanted a treatment plant in the neighborhood, so it was erected on an offshore fill near the Corey Causeway. (COSPB.)

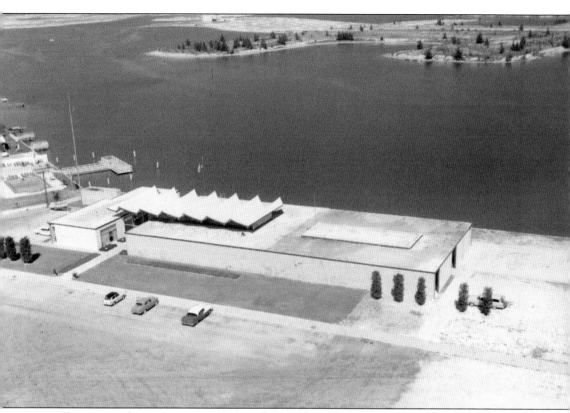

A small amount of money remained from the bonds sold to finance the defunct municipal auditorium. The commission voted to use the funds for a multipurpose center attached to the south side of city hall. (COSPB.)

Equipped with a kitchen and movable tables and chairs, the expansive annex could accommodate a variety of activities—from neighborhood association get-togethers to school-break camps, as seen here. (SS.)

Children found the sidewalks around city hall perfect for skate boarding and the seawall behind it an above-average fishing spot. (SS.)

A recreation director was hired to schedule programs all over the city. Swimming at the Island Club pool, baseball and tennis at Washington Park, and fishing at the Merry Pier were some of the first offerings. (COSPB.)

YOU ARE INVITED

TO BECOME A MEMBER

of

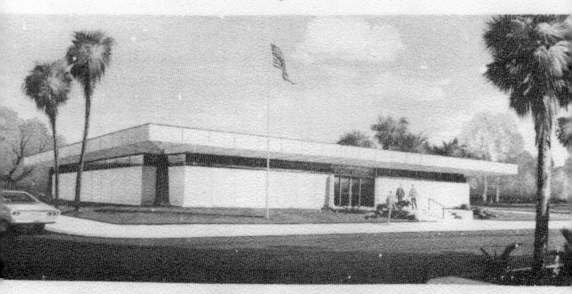

𝕱riends of 𝕷ong 𝕶ey 𝕷ibrary, 𝕴nc.

When the city made the decision to go ahead with a new library building in 1968, a Friends of the Library group was organized to raise money to help pay the construction costs. Library Advisory Committee chair Helen Weber stepped up to be the first president of the Friends. (St. Pete Beach Library.)

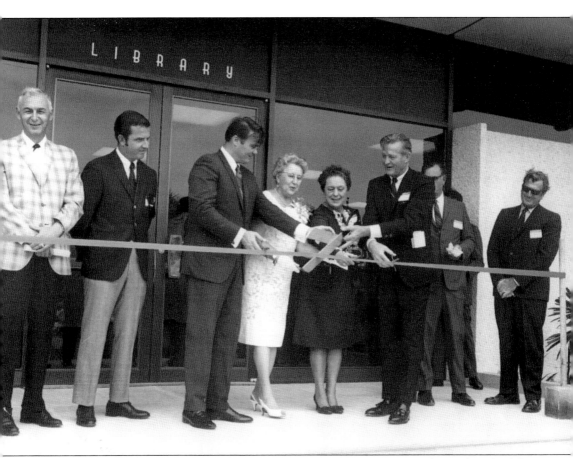

After nearly a year in temporary quarters on Corey Avenue, the library was finished in the fall of 1969. Cutting the ribbon on Sunday, October 5, from left to right, are state senator Bill Young (center); Helen Weber, Friends chair; Julia Rettberg, board chair; and St. Petersburg Beach mayor Richard "Dick" Ercius. (GBHM.)

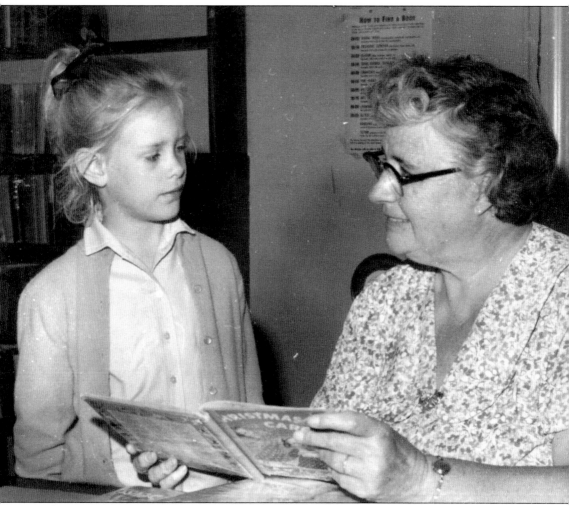

The conference room in the new building was named for Dorothy Heath, the head librarian since 1951. Heath, a member of the Community Club, had worked in the book department of Wanamaker's department store in New York. (SPBCC.)

The city's $100,000 federal library construction grant required a director with a graduate degree in library science. William Barnett, a business and science librarian with a Master of Library Science degree from Indiana University, got the job. In this photograph, he is welcomed to St. Petersburg Beach by members of the Community Club. (SPBCC.)

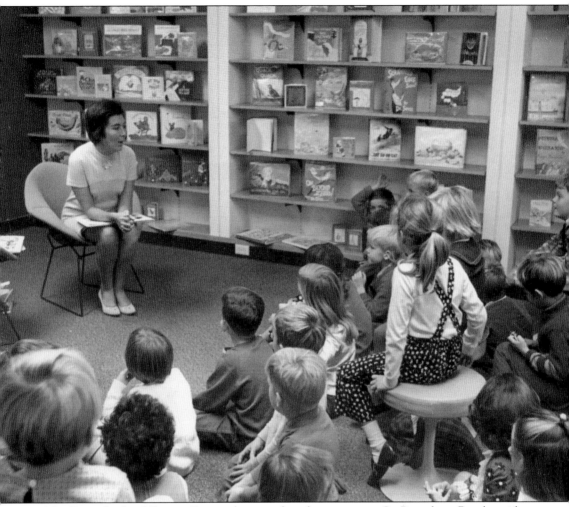

Miss June, the local *Romper Room* television show hostess, was a St. Petersburg Beach resident. She kicked off the library's children's programs with a special story time on November 15, 1969. (GBHM.)

In 1975, a gymnasium, a meeting room, a recreation office, and lockers and showers were added on the land occupied by city hall. The meeting room was named for former Community Club president Rebekah Upham. Girls as well as boys registered for the new kids' basketball leagues. (SS.)

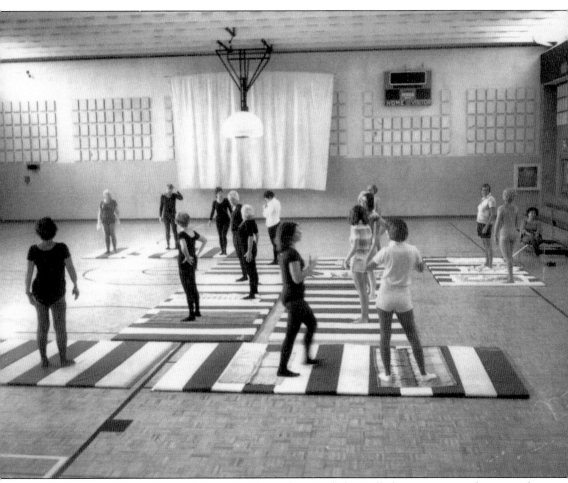

The gym soon became the place for anything that needed a really big space: teen dances, judo and Jazzercize classes (pictured), band practice, cheerleading workshops, community theater, the city's annual hurricane forums, indoor carnivals, and group garage sales. (SS.)

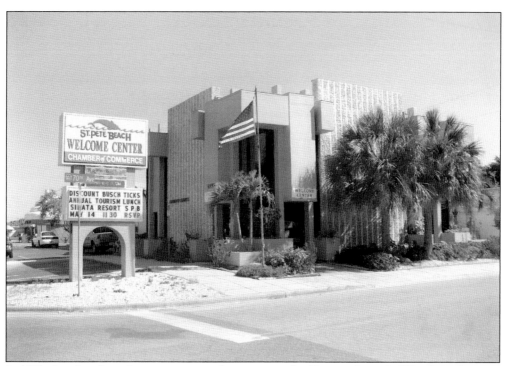

In 1971, the chamber of commerce moved into its own building on busy Gulf Boulevard, giving the police department full use of the north wing at city hall. (GBHM.)

For many years, utility trucks, mowers, and street sweepers were housed in lots between Ninth and Tenth Avenues in Pass-a-Grille. In 1974, in an effort to bring all municipal offices together, the city erected this public works garage on property just south of city hall. (COSPB.)

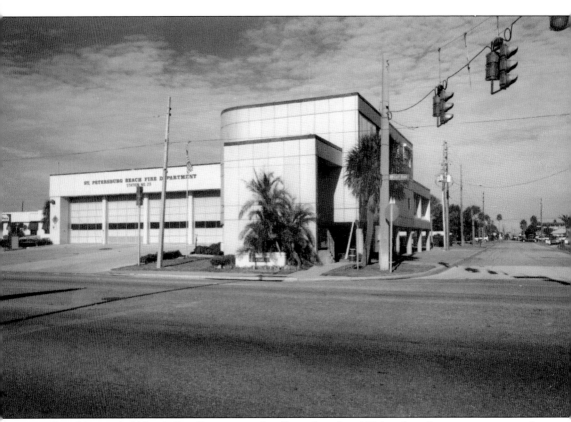

The old, crowded North Fire Station was finally replaced in 1984 with a three-story, storm-safe building at 7301 Gulf Boulevard. Between it and the South Fire Station in Pass-a-Grille, there were then 23 paid employees and 35 volunteers, 6 pumper trucks, 2 aerial trucks, 1 generator truck, and 1 rescue vehicle. (GBHM.)

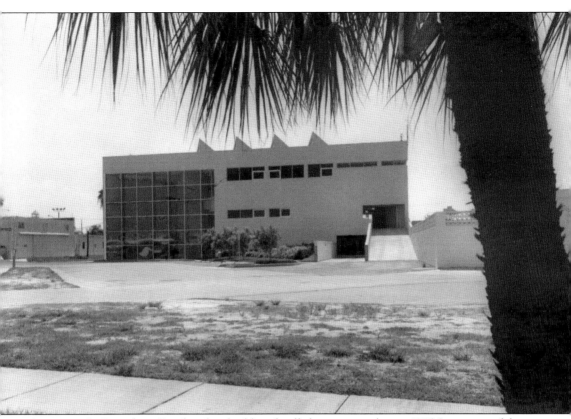

A separate St. Petersburg Beach police building finally became a reality in 1995. It was one of the first structures motorists saw coming into the city from the Corey Causeway. (GBHM.)

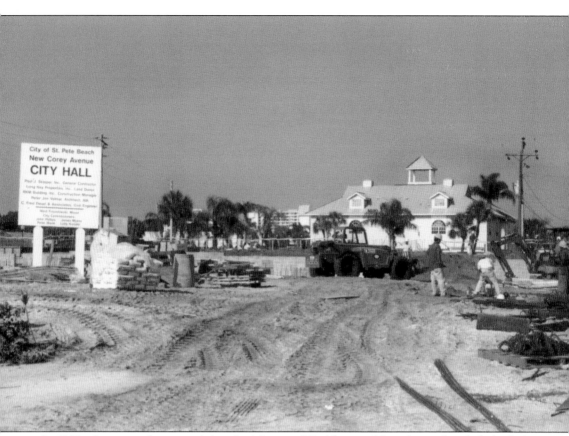

In 1999, after it was determined that the Municipal Building could not be easily refurbished, the commission looked for another site for city hall. Fortunately, a property on Corey Avenue was available. (GBHM.)

Seven

AN ECLECTIC GROUP OF
BUSINESSES

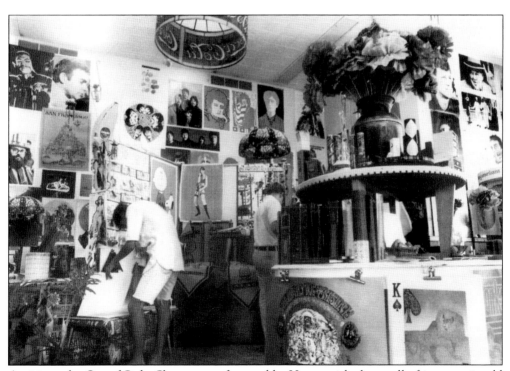

A visit to the Out-of-Sight Shop was unforgettable. Heavy with the smell of incense, it sold profane T-shirts, imported cotton clothing, pop art posters, beaded curtains, black lights, and smoking accessories. Remarkably, store owner Newt Simmons' run (1968–1993) in the old First Federal Savings building lasted much longer than the hippie era. (SPT.)

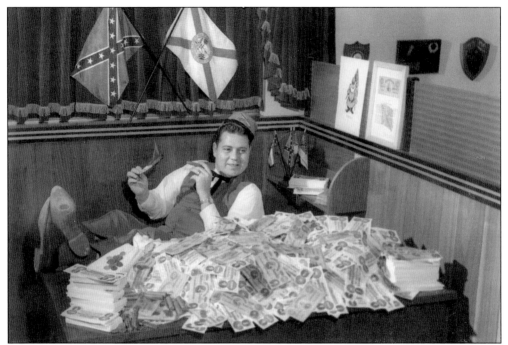

Former St. Petersburg Beach mayor Grover Criswell was the previous tenant at 401 Corey Avenue. His childhood passion for Confederate money turned into a profitable lifelong career and gave him international fame. (GBHM.)

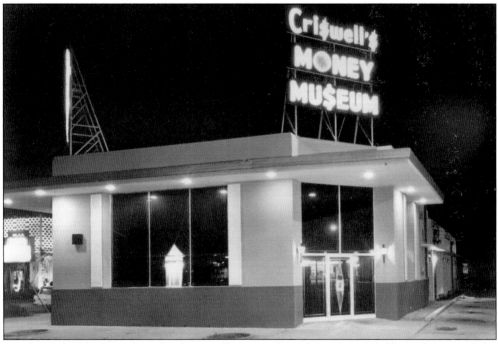

Few locals had known about his large collection of Civil War coins, bills, and memorabilia before he put it—and a variety of ancient, foreign, and obsolete currency borrowed from fellow numismatists all over the world—on display in Criswell's Money Museum. (GBHM.)

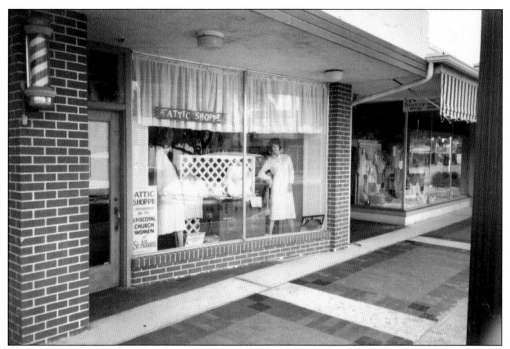

The St. Alban's Episcopal Church Women's Attic Shoppe has been a fixture on Corey Avenue since 1964. Annabel Carson reportedly protested its arrival, saying that despite its charitable mission, a resale store would "bring down the street." (Jane Gaugh.)

From its start in the 1950s, Scottie's News was a perfect match for St. Petersburg Beach's tourist trade. It carried many out-of-town papers as well as an assortment of foreign magazines. Later, when the popular London Pride shop lost its lease, Scotties took over the British market, selling McVities biscuits, Colman's sauces, and Typhoo tea. (RLW.)

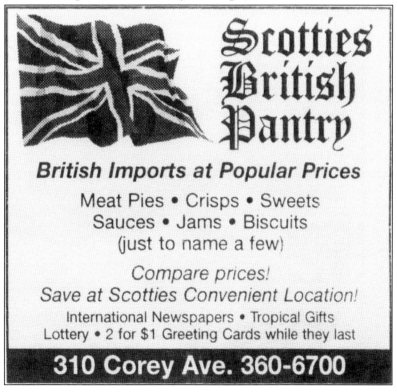

Scotties British Pantry

British Imports at Popular Prices

Meat Pies • Crisps • Sweets
Sauces • Jams • Biscuits
(just to name a few)

Compare prices!
Save at Scotties Convenient Location!

International Newspapers • Tropical Gifts
Lottery • 2 for $1 Greeting Cards while they last

310 Corey Ave. 360-6700

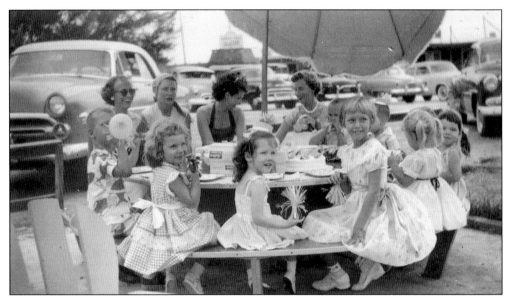

In the 1950s, lucky St. Petersburg Beach preschoolers, like five-year-old Carolyn Lamb (center, front) and her four-year-old sister Robbie (far right), received a birthday party at Playland Park. The outdoor amusement center, at the end of the Corey bridge, featured junior-sized rides, including a baby roller coaster. (RLW.)

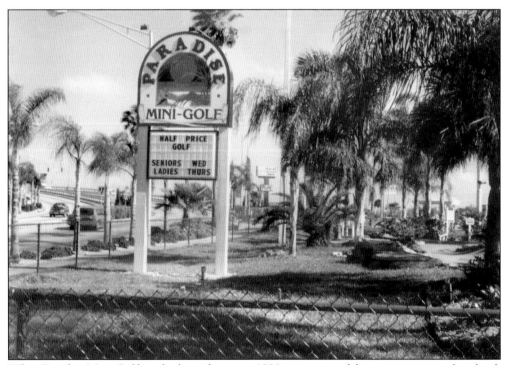

When Paradise Mini-Golf was built on the site in 1988, it was one of three putt-putts on the island. Players checked in at the faux lighthouse office, then proceeded to the challenging, multilevel 18-hole course. (GBHM.)

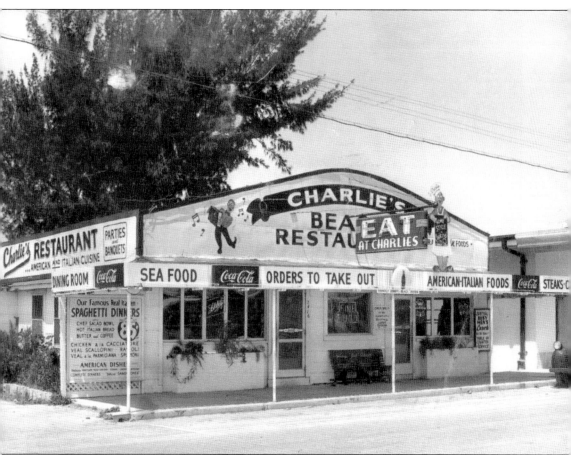

From 1952 to 1999, Charlie's Oasis, at 678 Seventy-fifth Avenue, was everybody's "good time place." Owner Charlie Watkins played the banjo and guitar, his son Dick the accordion. The audience joined in on the old-fashioned songs, danced joyfully through the aisles, and laughed at the silly vaudeville skits. (BH.)

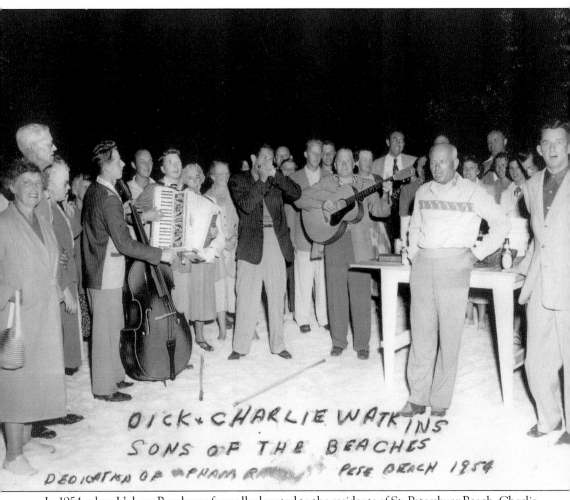

In 1954, when Upham Beach was formally donated to the residents of St. Petersburg Beach, Charlie and Dick Watkins and their Sons of the Beaches band led the festivities. (GBHM.)

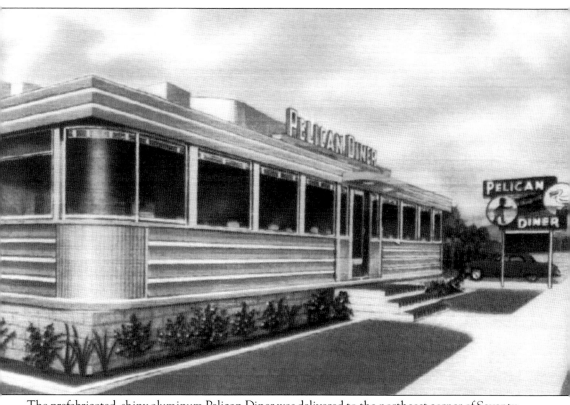

The prefabricated, shiny aluminum Pelican Diner was delivered to the northeast corner of Seventy-fifth Avenue and Gulf Boulevard in 1951 and remained intact when Hurricane Elena passed by in 1985. The distinctive sign with the boy taking a fish from the mouth of a pelican was not so fortunate, disappearing in the storm. (RLW.)

Welcome To Breakfast At

The Pelican Diner

Breakfast served All Day

From The Grill

One Egg, Any Style	2.10
One Egg, Any Style with Bacon or Sausage	3.20
Two Eggs, Any Style..........No Pot (2.20)	2.70
Two Eggs, Any Style with Bacon or Sausage	3.75
Two Eggs, Any Style with Virginia Ham (1/3 lb)	5.55

Above served with Potatoes or Grits and Toast with

Omelettes

Cheese	3.70	Western	5.25
Spanish	4.50	Mushroom	4.85
Ham...1/3 lb	5.55	Bacon or Sausage	4.45

Above served with Potatoes or Grits and Toast with Jelly

Hot cakes

Short Stack (2 cakes).....Single Cake (.95)	1.85
Hot Cakes (3) with Syrup	2.70
Hot Cakes (3) with Two Eggs	3.85
Hot Cakes (3) with Bacon or Sausage	4.05
Hot Cakes (3) with Ham	5.15

Malted Waffles

w/ Syrup	3.35	w/ Ice Cream	4.20

Add Whipped Cream for........... 50

French Toast........... 2.10 Raisin Brd French Tst 2.50

More Breakfast Selections on next Page

For 32 of its 50 years, the Pelican's owners were Helen and Ziggy Radvil, who served up good, classic diner food, using recipes handed down from the original proprietor. Breakfast dishes were bestsellers. (Will Jacoby.)

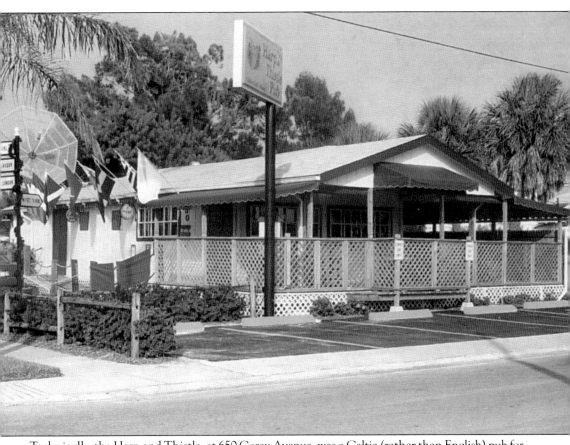

Technically, the Harp and Thistle, at 650 Corey Avenue, was a Celtic (rather than English) pub for the Irish wife and Scottish husband who opened it in 1984. Pat and Bob Packer celebrated St. Patrick's Day twice a year—once on March 17 and again six months later, on September 17. (PP.)

Fun-loving Bob, Pat, and their daughter Jennifer loved to dress the part. The family had previously operated an Irish pub in Detroit. (PP.)

Davy Jones' Locker, a colorful nightclub at the edge of the Corey district in the 1950s and 1960s, brought in entertainers from New York and Las Vegas, like the Musical Maniacs, the Punchinellos, the Leslie Marlowe Femme-Mimics Group, Kaye Stevens, and Bob Eberly. (RLW.)

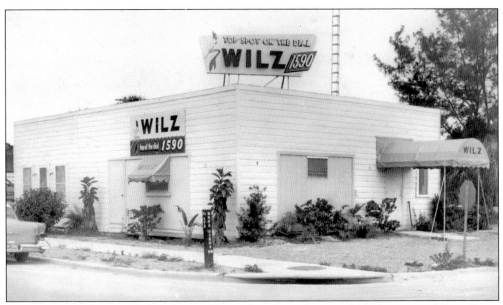

WILZ, 1590 on the AM dial, with an office and studio at Seventy-fifth Avenue and Boca Ciega Drive, went on the air on July 1, 1957. It was the first (and so far only) commercial radio station on the Pinellas beaches, then known as the "Holiday Isles." (GBHM.)

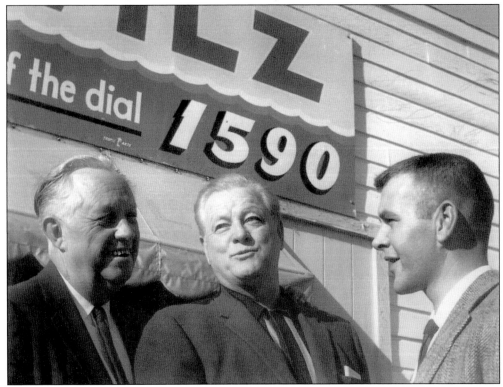

Future St. Petersburg Beach commissioner and mayor Ron McKenney, posing between radio legends Gene Austin (left) and Elmo Tanner, was one of WILZ's announcers. The independent station specialized in nostalgic music and local news and sports. (GBHM.)

The Art Gallery's Arthur Trock and Morris Stone definitely had a seasonal business, spending their summers in North Carolina and their winters in St. Petersburg Beach. High bidders took home a variety of fine goods and/or jewelry. (RLW.)

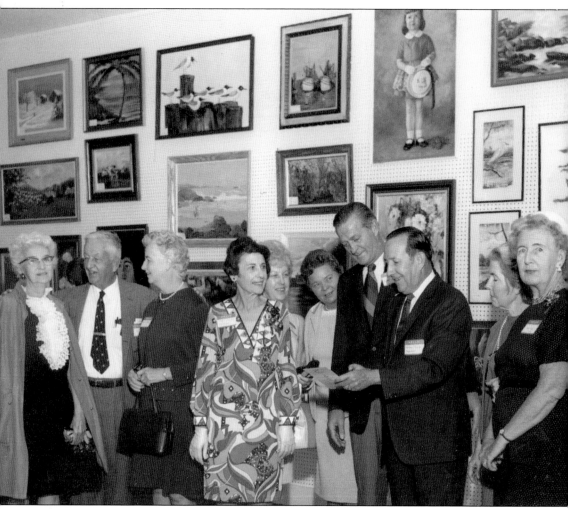

The Suntan Art Center, a nonprofit volunteer group of artists and art lovers, got its start on Corey Avenue in 1963. Here members welcome St. Petersburg Beach mayor Richard Ercius (fourth from right) to one of the group's monthly shows. (GBHM.)

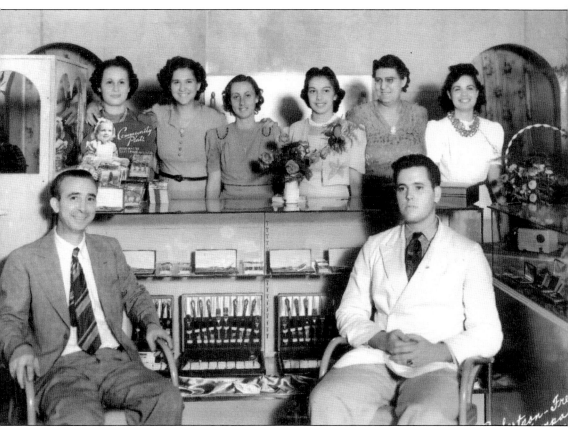

Corey Avenue has always had at least one jewelry store. The D'Elia family, originally from Tampa, became the first tenants in the First Federal of St. Petersburg building. The founder's grandson now operates Pasadena Jewelers. (Phillip D'Elia.)

INTERNET OUTPOST CAFÉ

SAVE TIME AND MONEY....

BOOK YOUR HOTEL OR AIRLINE RESERVATIONS ON THE INTERNET.

7400 Gulf Blvd @ Corey Ave in St. Pete Beach
360-7806 www.iocafe.net

Before hotels made free wireless available and the St. Pete Beach Library had more than a few computers, Kent Gustafson; his sister, Jodi Myers; and Tim Myers, Jodi's husband, launched the Internet Outpost Café at Corey Avenue and Gulf Boulevard. In addition to a high-speed connection, the café offered gourmet coffee, sweet treats, and classes on e-mail and the World Wide Web. (RLW.)

Eight

SPECIAL EVENTS

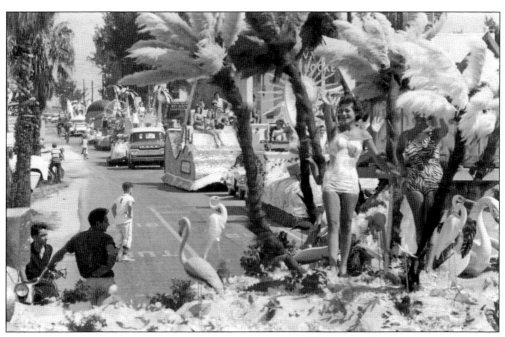

A Suntan Festival float heads toward Corey Avenue in 1959. All St. Petersburg Beach parades have started, run through, or ended on Corey. (COSPB.)

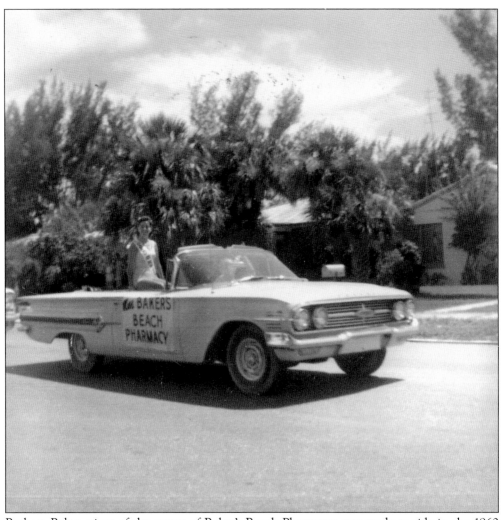

Barbara Baker, niece of the owner of Baker's Beach Pharmacy, gets ready to ride in the 1960 Suntan Festival parade. The Suntan Festival was held close to St. Petersburg Beach's July 9 anniversary. (BBS.)

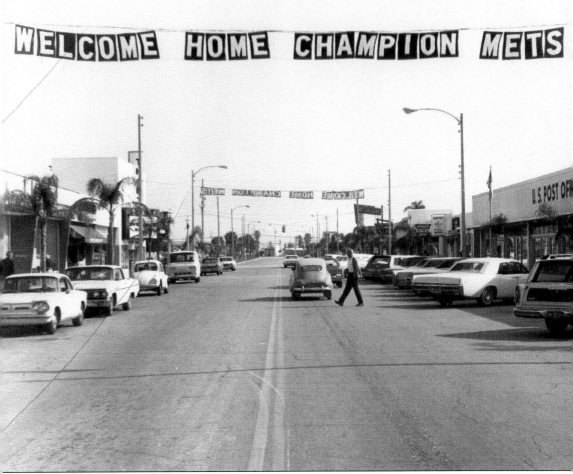

Corey Avenue celebrated the New York Mets' 1969 World Series win when the team returned to the area in March 1970 for spring training. The Mets had stayed in St. Petersburg Beach during their first few preseasons. (GBHM.)

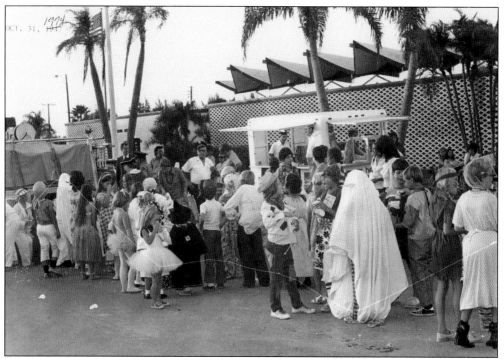

For many years, Halloween always began with a costume contest and carnival at the Community Center and continued with trick-or-treating on Corey Avenue. (SS.)

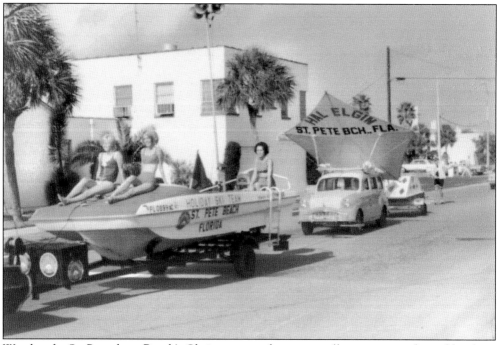

Weather for St. Petersburg Beach's Christmas parades was usually warm, as indicated by these bathing suit–clad ladies from Hal Elgin's Ski School. Here their boat passes by the funeral home. (SS.)

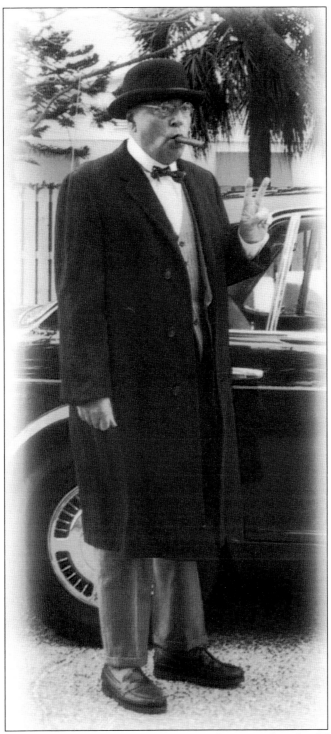

After St. Pete Beach acquired a British sister city—Sandown, on the Isle of Wight—Winston Churchill (actually resident Michael Berkowitz) appeared regularly in Christmas parades. (*Paradise News.*)

Judges sat in front of Fire Station No. 23, at Seventy-third Avenue and Gulf Boulevard—right before the parade turned onto on Corey Avenue, its final leg. Awards were given in several categories. (SS.)

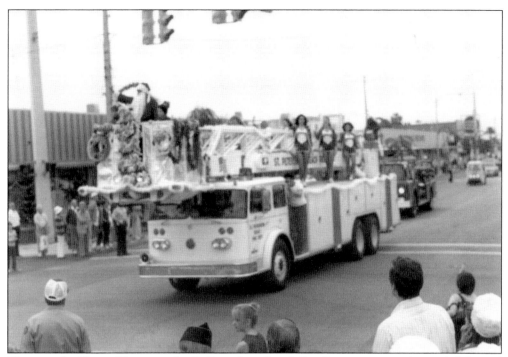

The arrival of Santa Claus atop the St. Petersburg Beach Fire Department truck signaled the end of another year's Christmas parade. (SS.)

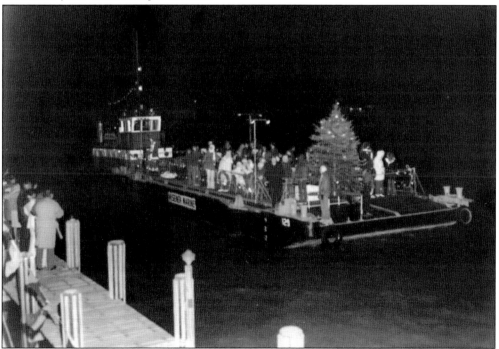

Richard Misener provided the barge for the Pass-a-Grille Community Church choirs' annual Christmas caroling event through the fingers of St. Petersburg Beach. Carolers boarded the decorated barge at Misener Marine's office near the Corey bridge. (BBS.)

Howard Alan art festivals have filled Corey Avenue several weekends every year since 1993. They are a major fund-raiser for the merchants' association. (RLW.)

the Island Community Theatre, Inc. *Presents:*

"A Corey Avenue Theatre Stroll"

Directed by Ciara Carinci

A live theatre **presentation of multiple one-act plays**
(adult comedy and drama)
Held in an open-air theatre realm along the walkways
of the Historic Corey Avenue Shopping District.

February 3rd, 4th & 5th Showtimes: 8 p.m.
February 6th Showtime: 2 p.m.

All performances begin at the St. Pete Beach Library
365 - 73rd Avenue, St. Pete Beach, Florida

After gathering for the performance, you will be "tickled" by the "Supreme Beings," then guided
along your way to the first play location. Parking is available at the library parking lot for each show

(You can bring your beach chairs with you)

Tickets:
$11 at the Door
$9 in advance*
Call: 363-6607

*Advance tickets must be
reserved by February 1, 2000

Tickets Available at these Beach Locations:

Color For All Seasons	**Books & Bagels on the Beach**
A Unique Boutique	Home of the T.I. Post Office
334 Corey Ave.	119 - 108th Ave.
St. Pete Beach	Treasure Island
367-8953	367-8029

The Island Community Theatre used the stage in the city's gymnasium for most of its productions.
In February 2000, it literally took to the street (Corey Avenue, that is) with a series of original
one-act plays. (ICT.)

123

The dressing room for the actors was the Color for All Seasons boutique. Here Michael Finn prepares for his role in the skit "Hard Change." (ICT.)

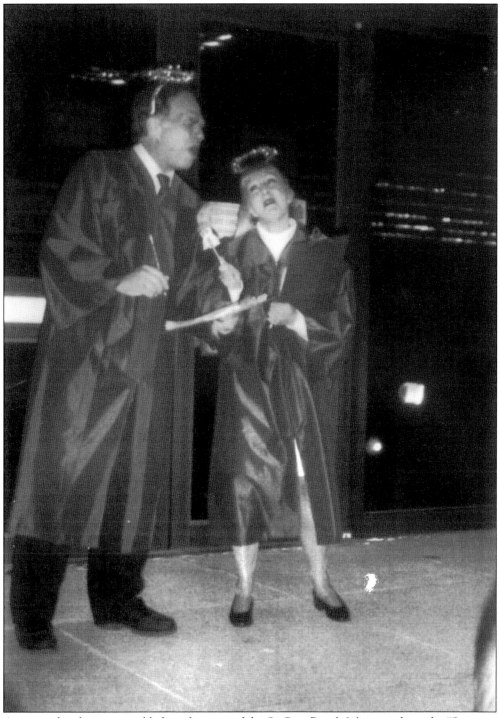

Actors and audience assembled on the steps of the St. Pete Beach Library to hear the "Supreme Beings" introduce the evening's entertainment. (ICT.)

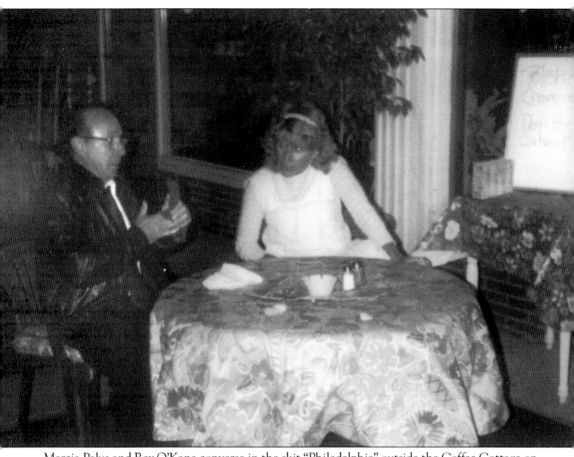

Marcia Palus and Ray O'Kane converse in the skit "Philadelphia" outside the Coffee Cottage on Corey Avenue. (ICT.)

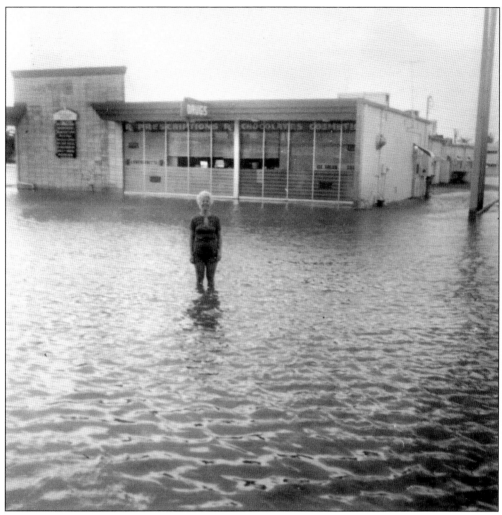

Thankfully, bad storms have been a rare occurrence in St. Petersburg Beach, with most hurricanes remaining far out in the Gulf of Mexico. When Hurricane Agnes passed by in 1972, though, it brought flooding to Corey Avenue. Here Mildred Baker stands in ankle-deep water outside her family's drugstore. (Mildred Baker.)

DISCOVER THOUSANDS OF LOCAL HISTORY BOOKS FEATURING MILLIONS OF VINTAGE IMAGES

Arcadia Publishing, the leading local history publisher in the United States, is committed to making history accessible and meaningful through publishing books that celebrate and preserve the heritage of America's people and places.

Find more books like this at
www.arcadiapublishing.com

Search for your hometown history, your old stomping grounds, and even your favorite sports team.